THE FINAI

This book offers a unique perspective on crafting your screenplay from an editor's point-of-view. Special features include before and after examples from preproduction scripts to post production final cuts, giving screenwriters an opportunity to understand how their screenplay is visualized in post production.

By the time a script reaches the editing room, it has passed through many hands and undergone many changes. The producer, production designer, director, cinematographer, and actor have all influenced the process before it gets to the editor's hands. Few scripts can withstand the careful scrutiny of the editing room. This book reveals how to develop a script that will retain its original vision and intent under the harsh light of the editing console. It provides insights that writers (as well as producers and directors) need and editors can provide for a safe journey from the printed page to the final release.

This book is ideal for aspiring and early career screenwriters, as well as filmmakers and established screenwriters who want to gain a better understanding of the editing process.

John Rosenberg, ACE, MFA, is a film editor, writer, and professor. He teaches the aesthetics of motion picture editing at USC's School of Cinematic Arts, where he is also the Core Curriculum Coordinator for undergraduate production. He has taught extensively throughout Asia. For over 30 years, Rosenberg has worked as a feature film editor, as well as a writer, producer, and production executive, for such companies as 20th Century Studios, New Line Cinema, Alpine Pictures, Orion Pictures, and Artisan. He is a member of American Cinema Editors (ACE). Along with feature work, Rosenberg has written and edited a variety of reality-based TV projects, including for National Geographic. He is the author of the award-winning novel *Tincture of Time* as well as the popular film book *The Healthy Edit: Creative Editing Techniques for Perfecting Your Movie*, currently in its second edition and recently translated into Mandarin.

THE FINAL REWRITE

How to View Your Screenplay with a Film Editor's Eye

John Rosenberg

Routledge
Taylor & Francis Group

NEW YORK AND LONDON

Cover design credit: artwork by Michael Rosenberg

First published 2023
by Routledge
605 Third Avenue, New York, NY 10158

and by Routledge
4 Park Square, Milton Park, Abingdon, Oxon, OX14 4RN

Routledge is an imprint of the Taylor & Francis Group, an informa business

© 2023 John Rosenberg

Library of Congress Cataloging-in-Publication Data
Names: Rosenberg, John, author.
Title: The final rewrite : how to view your screenplay with a film editor's eye / John Rosenberg.
Description: New York, NY : Routledge, 2023. | Includes bibliographical references. |
Identifiers: LCCN 2022049184 (print) | LCCN 2022049185 (ebook) | ISBN 9780367752262 (hardback) | ISBN 9780367750596 (paperback) | ISBN 9781003161578 (ebook)
Subjects: LCSH: Motion picture plays--Editing. | Motion picture authorship.
Classification: LCC PN1996 .R677 2023 (print) | LCC PN1996 (ebook) | DDC 808.2/3--dc23/eng/20230127
LC record available at https://lccn.loc.gov/2022049184
LC ebook record available at https://lccn.loc.gov/2022049185

ISBN: 978-0-367-75226-2 (hbk)
ISBN: 978-0-367-75059-6 (pbk)
ISBN: 978-1-003-16157-8 (ebk)

DOI: 10.4324/9781003161578

Typeset in Sabon
by SPi Technologies India Pvt Ltd (Straive)

CONTENTS

CONTENTS

ACKNOWLEDGMENTS

I gratefully acknowledge the help of many in putting this book together. First, to my wife Debbie Glovin Rosenberg, the perennial first editor who read an initial draft and gave stellar, insightful notes. Also, my gratitude to Cindy Davis of the University of Michigan and Eric Young of Chapman University who read an early draft and gave terrifically helpful and specific comments. Also, much gratitude goes to acquisitions editor Katherine Kadian, who first promoted the book to the publisher, and to my wonderful and patient editor Daniel Kershaw and his immensely helpful and gracious assistant Genni Eccles who helped shepherd the book through the editorial process and out into the world. Much gratitude is also due to production editor Eleonora Kouneni and copyeditor Louise Smith. Credit is due to Script Slug for supplying some of the scripts that are quoted herein. Thanks also to Tod Goldberg, Joshua Malkin, Mark Haskell Smith, and Mary Yukari Waters of the UC Riverside Creative Writing and Writing for the Performing Arts MFA program. To world class composers and dear friends Garry Schyman and Mark Adler whose music has enlivened my work over the years. And to my friend and colleague James Savoca whose presentation when we guest lectured at Shanghai Film Academy encouraged me to write about filmic moments. Also, to my colleague and friend Brad Barnes for his insights into directing "*feels*." To the world-class faculty and staff at USC's School of Cinematic Arts, including Dean Elizabeth Daley, Vice Dean of Faculty Akira Lippit, who encouraged my sabbatical to allow more time to write, Vice Dean Michael Renov, Associate Dean Alan Baker, Chair of Production Gail Katz, Vice Chair Susan Arnold, previous Chairs Mike Fink, Barnet Kellman, and Michael Taylor, Assistant Chair Cedric Berry, Editing Track Head Nancy Forner, ACE, and to all our students who make USC SCA one of the top film schools in the world. Finally, to my daughter Sarah who encouraged the writing of this book, to my son Michael who created the artwork and designed the book cover, to my parents, Maryanne and Frank P. Rosenberg, and to our family friends who were some of the greatest writers of their time – Julie Epstein, Sid Fleischman, Ben Hecht, Ernie Lehman, Dick Maibaum, Rod Serling, Dan Taradash, and Ernest Tidyman. Their love of storytelling captivated and inspired me when I was young and impressionable.

INTRODUCTION

Experienced screenwriters know the importance of rewriting. The grue-some sounding dictum to "Kill your babies" is not the tag line of a horror film, but an oft repeated phrase among writers as they self-edit. It sug-gests that writers must be willing to give up material they're in love with for the greater good of the screenplay. But it's not just about infanticide. Sometimes it's about adding, trimming, rearranging.

If it weren't for the writers who brave the blank page to create a screen-play, film editors would have nothing to work with. For those writers, this book will help make the process easier, by seeing their work through the eyes of the film editor who is the privileged guardian of their work and the purveyor of the final rewrite.

In the literary world the writer has the book editor; in the film world the screenwriter's work is ultimately finished by the film editor. Along the way the script may encounter development executives, directors and pro-ducers who give valuable input (or not), evolving the screenplay from the original script to a shooting script. Ultimately the test of what will appear on screens throughout the world falls into the hands of the film editor. Since film is a translation process from script to dailies to the final cut, the film editor has significant influence on a film's final outcome.

As an editor and writer, I have noticed consistent issues of structure, tone, character and pacing that occur when a film is not working as well as it could. Writers, even with the best intentions to view their work objectively, sometimes overlook flaws that are obvious to editors. As one member of a highly collaborative process, however, the writer is not solely responsible for these issues. But by addressing them early in the process, screenwriters can strengthen their scripts, making them less sus-ceptible to unexpected or ill-advised alterations. In that regard, not only writers but also other key members of the filmmaking process will benefit from the insights contained here.

Unlike novelists who work directly with book editors, screenwriters rarely if ever have direct contact with the film editor. By that point in the

DOI: 10.4324/9781003161578-1

process, the script has already passed through at least two permutations – the writer's rewrite and the director's (and more if one includes producers and development executives). It eventually comes to rest with the film editor.

In this book, we are exploring the alpha and omega, the beginning and the end of the process. In Greek mythology, the character of Mercury had the uncanny ability of dashing between the highest and the lowest, the sublime and the tawdry. He visited all realms, but found attachment to none. That could be the description of a film editor.

From the start, the editor sees with different eyes, a sort of meditative detachment. She can let go of one thing in order to conjure something better in its place. She can explore with intricate detail or stand back and view the entire landscape. And she controls time.

The moment an editor makes a cut he has altered time, a privilege that few humans enjoy. As the Webb telescope has shown us, time is a matter of perception and in the present we can view a long lost past.

Without the introduction of a cut, time continues linearly, as we experience it in reality, our quotidian perception of the chain of events. But with the introduction of a single cut, time is altered. It will accelerate rapidly forward at a dizzying rate or it will linger, hover, suspend. Either way, the cut must arouse emotion, it must influence the viewer's heart and mind.

In film, the final outcome rests in the mercurial hands of the editor, the one who magically makes objects, people, feelings appear and disappear, who alters time, who tickles us and plays with our concepts of reality, whether through complex visual effects or a simple cut. But it all begins with a script.

1

THE FINAL REWRITE

This chapter introduces the basic issues that confront writers and editors. It suggests how they will be dealt with throughout the book. It includes case studies as well as an overview of writing and editing.

The first cut of the most expensive film in 1936 ran six hours long. It was nearly unwatchable. In collaboration with the film's director, Frank Capra, the editors, Gene Havlick and Gene Milford, trimmed it down to 3 ½ hours. Even at that length the audience was unreceptive and many walked out.

Jump ahead to the next preview screening and a lucky accident. When the projectionist threaded up the film, he mistakenly left out the first reel, and started with the second reel. The film significantly improved.

Taking a hint from this, the director and editor rethought the opening and decided to remove the first *two* reels for the next screening. The film played even better. It turned out that all the preamble and backstory of those first two reels wasn't necessary. It worked better to start in the midst of the action and allow the audience to catch up, to bring their own intelligence to bear on the film.

None of this had been anticipated when *Lost Horizon* was first conceived. The script was lauded over, preproduction was carefully planned, and scenes were extensively covered during production. When it arrived in the editing room, the editors were buried under thousands of feet of film for months. But the final film was nothing like the one that was originally scripted. It often isn't. If only the filmmakers had the foresight that hindsight brought, it would have saved them months of work, bundles of money, and hours of anguish.

There are few scripts, if any, that can stand up flawlessly to the scrutiny of the editing room. In the editing room all the best intentions and the worst mistakes are exposed.

DOI: 10.4324/9781003161578-2

Decades after *Lost Horizon*, and after thousands of other motion pictures have splashed upon theater and television screens, we have the opportunity to understand the editing process in a new way, in a way that sheds light on the writing process, the genesis of it all. In more recent times, *Schindler's List* writer Steven Zaillian made a similar observation as it relates to the editing process. In *On Story: Screenwriters and Their Craft*[1], Zaillian noted that

> "At some point in editing I realized that, with most things I was working on, you could take out the first reel, just throw away the first ten minutes, and start the movie where the action starts. That way you'd get to know the character over the course of the real action and not as a kind of preamble. That's something I'm actually very conscious of doing now, thinking about what happens before the story really gets going but not writing it."

In a sense, the end informs the beginning. Basic editing concepts such as transition, montage, pacing, rhythm, structure, intercutting, point-of-view, sound effects, visual effects, and the creation of what we'll call **filmic moments** can guide writers, producers and directors during script development and preproduction stages as much as these techniques guide the editor throughout post production.

This book will reveal how to bulletproof a script so it retains its original vision, its primary concerns, and its initial intent in the sometimes harsh light of the editing console. From the starting point to the finish line, the melding of the writer's goal and the editor's insights lead to successful filmmaking.

For Writers. As screenwriter Cindy Davis points out, it is important to keep in mind that "producers, studio execs, directors -- usually have far less knowledge about story structure and characterization than the screenwriter, but the screenwriter is required to execute their notes. An editor rarely sees the draft of the screenplay that the screenwriter loved."

With the introduction of high-definition digital capture, the volume of raw material has increased many fold since the single-camera 35mm celluloid days when most films consumed anywhere from 50,000 to 150,000 feet of film. The ease and low cost of digital file-based production gave filmmakers greater liberty to shoot as many takes as they deemed necessary, limited by time rather than cost. Even in the celluloid era, however, the numbers kept growing. The 1961 classic western *One Eyed*

Jacks, directed by Marlon Brando, nearly doubled the anticipated film consumption[2]. In the waning years of celluloid's dominance in the early 2000s, directors were beginning to shoot well over a million feet of film. All this while knowing that their final movie would come in at around 12,000 feet or less, the equivalent of a two hour movie.

For Editors. 35mm film runs at 24 frames/second through both the taking end – the camera – and the exhibition point – the projector. That equates to 90 feet per minute. Most films run no longer than two hours.

First Man

A recent example of the editor's ability to rewrite a script through the use of coverage occurs in *First Man* (2018) a dramatic retelling of Neil Armstrong's life in the Gemini space program. Like other high profile films by high profile directors, *First Man*, was still shot on celluloid film. Nearly two million feet of the stuff. Around 370 hours of footage.

Whether captured digitally or on film, the huge increase in coverage has invited editors to invest more and more of their creative time and technical skills into the storytelling process. This is certainly the case for *First Man* editor Tom Cross, ACE. According to Cross[3], "(The director) knew we would do a lot of writing in the editing process. ... He shot an enormous amount of footage, so there was a lot of leeway for rewriting in the editing room."

Coverage has a different meaning for screenwriters than it does for film editors. In the editing room, coverage refers to all the material that was shot in order to capture the scene, usually involving multiple set-ups or angles such as wide shots, medium shots, close-ups, and so on. This allows the film editor to assemble the scene in the best way possible. For writers, coverage refers to a review of the screenplay done by professional readers, usually for a studio, agency or production company.

Some scenes in *First Man* had improvised performances that deviated from the original script. Even when the director "would shoot the scene as scripted, he would often have a second camera to roam around capturing other characters."

"Editing is really the final rewrite of all movies," concludes Cross. He should know, since he was also responsible for the final rewrite of other highly successful films such as *La La Land* (2016) and *Whiplash* (2014), both which required extensive rewriting in the editing room.

During the editing of First Man, Cross found that the addition or deletion of a few frames made a huge difference.

> "For example, (in) the opening X-15 [test flight] scene...there are moments where, if we held too long on a gauge, it would break the illusion of urgency... If there's a series of insert shots or details played at just the right length, then there is a sense of urgency – they build upon each other."

This notion of shot length was first highlighted in the early days of filmmaking by one of the great theorists of cinema, Sergei Eisenstein. In developing his theories of montage he came upon the concept of **metric montage**, where the mathematics of a shot -- the precise length -- creates meaning when juxtaposed with surrounding shots. Writers often are not aware of this. But it's possible to build shot length and juxtaposition into a script, such as Martin McDonagh did in the Academy Award winning film, *Three Billboards Outside of Ebbing, Missouri* (2017).

In the dental office scene, the character Milfred (Frances McDormand) is at the mercy of an angry dentist, Geoffrey (Jerry Winsett), who is determined to discourage her attempts to uncover the facts about her daughter's death. But Milfred turns the tables on him and grabs his dental drill. Here the writer gives us quick, cut-like glimpses of the action:

```
CLOSE-UP: The drill gets closer and closer to
his thumbnail.
GEOFFREY sweating...

MILFRED determined...
...until finally the drill WHIRS INTO THE NAIL...
```

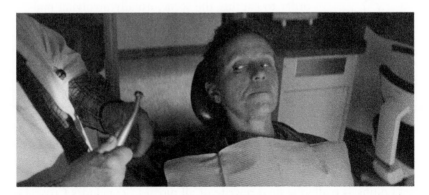

Figure 1.1 Three Billboards Outside of Ebbing, Missouri. Mildred visits the dentist.

Credit: Searchlight Pictures.

It is as if the writer had already conceived of how the film would be edited before it left the printed page. This is one of the goals -- to bring the shooting script and the final cut into closer proximity. Screenplays are not literary works in the manner of novels or short stories. These forms are ends in themselves while a film script is only the beginning of a long process involving sometimes hundreds, even thousands, of people, each contributing in their own way. Consequently, taking too literary an approach to a screenplay works against the process and encumbers it with extra verbiage, no matter how lovely the writer's use of language and description.

Here's another writer, Taika Waititi, who imagined his opening scene in *Jojo Rabbit* (2019) as a series unfolding shots. The images themselves, seemingly innocent at first, spark our attention and eventually impale us with the disturbing meaning that those images symbolize. Only after a while do we realize a kind of sardonic innocence that lies deeper down, incubating until it will eventually morph into true heroism. Jojo will confront his unquestioning fascist beliefs to risk his life and save a Jewish girl, Elsa, whom his mother is hiding in the attic.

```
INT. JOJO'S HOUSE - MORNING

We open with QUICK DETAIL SHOTS of a young
boy dressing:

-- A brown shirt buttoned.
-- Badges pinned.
-- Belt tightened.
-- Neck kerchief tied.
-- Socks pulled up.
-- Hair combed.
-- Shoes clicked together at the heels,
one foot stomps down hard on the floor.

He is dressed. We PULL to a CLOSE-UP,
coming face to face with our HERO…

JOHANNES BETZLER, (JOJO), a cute 10 year
old boy.

The room is covered with NAZI POSTERS and
other PARAPHERNALIA, including pictures
of ADOLPH HITLER. You guessed it, he's a
little Nazi.
```

So, what can writers take away from films like *First Man*, *Lost Horizon*, *Three Billboards Outside of Ebbing, Missouri* and *Jojo Rabbit*? An understanding of the editor's final rewrite can inform a writer's approach to drafts of their script, all the way up to and including the shooting

script. Conversely, a better understanding of scriptwriting will help editors incorporate structure, story and character into their cuts. It is truly a symbiotic relationship. Like Egyptian plovers picking food scraps from the giant molars of rhinoceroses, the editor's work benefits the story by removing anything that's unnecessary, ultimately benefitting the overall film.

Figure 1.2 Jojo Rabbit. Jojo gets dressed.
Credit: Searchlight Pictures.

Freshmen film students and the general audience often imagine editing as a process of merely sticking the pieces together. B follows A and C follows B. If you have the correct coverage and, as we'll see that can be a big *if*, you should be able to follow the instructions and stick it all together. But editing a film is not the same as putting together an Ikea desk set and, as with some do-it-yourself kits, parts are often left out.

In my classes, the jigsaw puzzle plays a role in introducing students to the complexity of editing and the various elements involved, such as collaboration, imagination, structure, and deadlines. They only have two minutes to put it together – thankfully, the pieces are rather large. But the pieces don't always fit together easily and, more than that, there are always a missing piece – I hide one. At times the students find it helpful to refer back to the script (in this case the picture of the completed puzzle on the box lid).

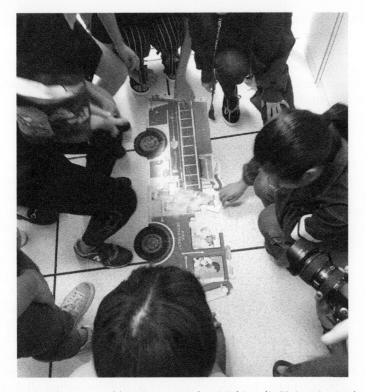

Figure 1.3 Students assemble a jigsaw puzzle – Multimedia University, Malaysia.

In her book, *Reading and Writing a Screenplay*[4], Isabelle Raynauld suggests that

> "...a screenplay should not simply recount a story, rather, it should foreshadow the future film. Each element of a screenplay, each sentence, should be written and read in the context of how these words will materialize on screen, through lighting, acting, physical space, framing, ambiance, sound, editing, actions, emotions and narrative..."

She echoes our approach when she suggests that "screenwriting ought to be based on the logic of film editing for it to be efficient and conducive to the production of film." Writing a screenplay requires the author to conceive of story in a fragmented way, putting together a puzzle, piece by piece, as in our jigsaw example.

Raynauld uses the term **synecdoche** to describe how "the whole is told through its parts...the story is a whole, but the whole story is untellable. We must choose which parts of the whole of the story are greater than us

and hold the most potential." Consequently, the screen story must fit into a particular time fame while ignoring unnecessary elements.

According to film theorist Jurij Lotman[5], "It is only when cinema decided to base its artistic language on editing that shot segmentation became a conscious element without which filmmakers cannot develop their discourse and the audience, its perception."

The Screenplay

Screenplays deal with story and character, which manifest as action and dialogue. When you look at a screenplay it's a fairly simple affair. Screenplays are more like poetry. Sparse, evocative and full of promise. Screenplays ask you to imagine who will play your protagonist, what the set will look like, how shots will be composed. Screenplays encourage you to imagine the meaning of the dialogue's subtext. This is what draws a producer or director to your project. This is what sparks the producer's imagination. The tease of the screenplay, the temptation that it holds is what entices a producer to buy it and a director to shoot it. And it had better have a great story as well. A good screenplay excites us with its promise, but in a sense the promise is unfulfilled.

No one knows going in what the film will really look like until it goes before the camera and before it lands in the editing room. Unlike a novel, poem or short story, the screenplay is only the beginning. It is not the end; it is not the entire or self-contained work. It requires others to bring it to life. So, its tease must be strong. Strong enough to withstand all that will be thrown at it. Even in the development stage it will be bombarded with endless notes, questions and suggestions, ideas that are sometimes brilliant and sometimes ludicrous.

Figure 1.4 Apocalypse Now – Captain Willard daydreams in a Saigon hotel.
Credit: American Zoetrope/United Artists.

Think of a logline. A good logline has multiple components. It introduces a character, it implies a story, and it offers a twist or sense of irony at the end. Its goal, like that of the screenplay, is to entice. A good logline sounds something like this: "During the Vietnam War a captain is sent on a dangerous mission into Cambodia to assassinate a renegade colonel who has set himself up as a god among the local tribe." This logline from *Apocalypse Now* (1979) piques the imagination. It asks us to imagine the challenges and obstacles that lie ahead. The film, one of the classics of that era and perhaps of all time, was based on the Joseph Conrad novel, *Heart of Darkness*. It had a solid script by John Milius. Yet after all the shooting was over, the film was drastically rewritten in the editing room over the course of two years until it finally found its way into the hearts and minds of filmgoers.

At the time the director, Francis Ford Coppola, shot an unprecedented million and a half feet of celluloid film. Disenchanted with the opening scene (and later with other scenes to come), the supervising editor, Richard Marks, cobbled together – albeit beautifully – a workable sequence from discarded footage he dug up from the cutting room floor. He knew that the opening, as written, wasn't working. The film needed something more. So he conceived of an **approach** – an essential aspect that we'll elaborate on later – and went looking for a way to manifest it. What he came up with, coupled to the song "The End" (given to the director by The Doors' lead singer Jim Morrison with whom Coppola had attended UCLA film school), changed the history of film.

No hint of this scene exists in the original script. In fact, the shooting script begins with a scene that occurs much later in the film, a head emerging out of a swamp in Vietnam. From here it transitioned to a spectacular metaphoric scene of fire and planetary nebulae and then to a luxury cabin cruiser docked in Marina del Rey, California. Only in the fourth scene did we meet Captain Willard (Martin Sheen), the main character, on a street in Saigon. He was not the haunted, desperate figure who is seen in a Saigon hotel room in the movie's final version. The script concluded with a gigantic battle scene, but director and editors wove the ending into a more mythic and disturbing finale involving the death of the reclusive Captain Kurtz (Marlon Brando). Slowly and painstakingly the film was rewritten in the editing room. In a similar way, discovering the essence of a scene or sequence can shepherd the writer beyond extraneous scenes, action and dialogue.

In production, the director generally follows the road map of the script. The action and dialogue as shot must reflect what is written. Directors bring their points-of-view and personal visions. By the time the film gets to the editing room, the script has pretty much been abandoned. It has new parents. It has become a new entity. And the **dailies** – that production

For Writers: Screenwriting Basics. Think first in terms of character and structure. Engaging, relatable characters with strong desires – strong enough to bring them into conflict with other characters – will fire up the plot. But the plot needs structure. Screenplays, unlike literary novels, rely heavily on structure. And structure often relates to genre (more on this later). Generally, screenplays run no longer than 120 pages. They have three acts. They have plot points occurring at the end of each act. The midpoint introduces a central conflict or crisis. Beyond the seemingly pedantic aspect of structure lies a wide open world of character and premise and setting that brings life to the seemingly confined world of form and outline.

footage that reflects the script -- is the new reality. Nothing exists except the footage that sits before the editor. Most editors throw the script away at this point. Sometimes figuratively, sometimes literally.

Editing is a journey of discovery. As most experienced filmmakers know, there's the film you thought you were making and then there's the film that you discover you are making. This is the one that you unearth in the editing room. Sometimes it closely resembles what you expected, but often it turns out to be something quite different. This can drive a writer crazy. How distressing for the mother who doesn't recognize her own child. On the other hand, if she embraces this fact, the writer will find in the editing process the kernel of the writing process and gain further insights into making a highly successful screenplay.

Whether it's *Lost Horizon* in the early years of the film industry or *Apocalypse Now* in the middle years or *First Man* in this current time, films have been rewritten in the editing room throughout the history of motion pictures. Now it is time to discover the inner workings of this process.

Notes

1 Austin Film Festival. *On Story: Screenwriters and Their Craft*. Edited by Barbara Morgan and Maya Perez. University of Texas Press, Austin. 2013.
2 Personal communication.
3 Interview by Richard Trenholm, Dec 12, 2018 in CNET.
4 Raynauld, Isabelle. *Reading and Writing a Screenplay*. Routledge, New York. 2019.
5 Lotman, 1977, p. 48. Translated by Isabelle Raynauld, 2019.

2

BEST INTENTIONS AND EXCELLENT FAILS

Where do things go wrong in the writing and development stages? Is it a lack of engagement, a dreary pace, a false character, a forced plot? How do these factors affect the post production stage of the process? How does this inform a writer's choices? How do editors confront this fact? How can the editing process fulfil expectations engendered by the script?

Not Quite Heaven

Early in my editing career I was the associate editor, with Tom Walls, on a film entitled *Made in Heaven* (1987). It had an excellent premise, so good that it garnered a large budget and the top Academy Award winning actors at the time. It was written by two excellent writers, Bruce A. Evans and Raynold Gideon whose previous film was the highly successful *Stand By Me* (1986). Yet this film had serious dramatic flaws.

The **premise** – a young man, Mike (Timothy Hutton) dies while doing a good deed and goes to Heaven where he meets a young woman, Annie (Kelly McGillis) whom he falls in love with. The twist is that she was "made in heaven" and has never been to Earth before. As she embarks on her maiden journey, Mike makes a deal to follow her back to Earth. They have 30 years to find each other, or else be lost to each other forever.

The premise evokes Plato's concept of Eros in his *Symposium* that posits that we have perfect other halves who, in finding them, will bring us happiness. A timeless and classic idea turned into a super clever premise. Except in its execution the script omitted one essential aspect of storytelling – an all pervasive need.

In Heaven, Mike has a desperate and clear desire -- to be reunited with Annie. But this need will eventually get misplaced when he lands on Earth. On Earth, neither he nor Annie has any idea that the other exists or that they are searching for their other half so as to eventually be eternally united.

DOI: 10.4324/9781003161578-3 13

For Writers: A **premise**, according to Merriam-Webster is "a proposition antecedently supposed or proved as a basis of argument or inference." In a story, the premise posits a problem that must be solved, after multiple attempts and obstacles on the way to finding a solution. The premise becomes the throughline that everything relates to. In a good story every possible avenue is examined on the journey to the final goal. Along the way, the premise carries the main conflict, continually reinforcing and elaborating on the issue that was stated at the beginning. This weaves through all the acts, no matter how many there are.

While in Heaven, Mike searches out Emmett (Debra Winger, uncredited, as a gruff Irishman who runs Heaven) and makes his request.

```
                    EMMETT
          The answer is no.

                    MIKE
          Is she a girl?

                    EMMETT
          The answer is no.

                    MIKE
          Is she a girl?

                    EMMETT
          Yes.

                    MIKE
          Then send me back as a boy.

                    EMMETT
          I can't do that.

                    MIKE
          You can do anything, Emmett.
          I know you can.

     Emmett gets up.
```

 EMMETT
 I didn't want to see you.
 How did you find me?

 MIKE
 The cigarette. You're the
 only one who smokes in Heaven.

 EMMETT
 Oh frock. Now that's in the air.
 I'll probably have to quit.

 MIKE
 I'm not asking you to put
 me next door, Emmett. Just put
 me in the same country and I'll
 find her.

 EMMETT
 Mike, the two of you fell in
 love in Heaven. One day you'll
 fall in love with her on Earth
 and you'll be together forever.

 MIKE
 When does that happen?

 EMMETT
 How would I know? Maybe one
 lifetime. Maybe two or two
 hundred. How would I know?
 But you'll love her again.

(Spoiler alert. We could probably end the movie here since Mike has already been reassured that he'll be together again with Annie. The question is *when*, not *if*. *If* is the more compelling question. It's never a good idea to give away the solution to the conflict. But Mike's impetuousness adds a small complication.)

 MIKE
 But I want to be with her
 now.

 EMMETT
 You'll be out of your time.
 You Americans drive me crazy.

> You're so impatient. You're
> going to mess everything up.
>
> MIKE
> I'm not happy without her.

Emmett turns and watches (some) dancers. Mike
waits.

> EMMETT
> I can only give you thirty
> years. And if you don't find
> her in that time, you'll never
> find her again.
>
> MIKE
> If I believe I can find her,
> I will, right?

The two men look at each other.

> EMMETT
> You hear what I'm saying to
> you, Mike. If you don't find
> her this time, she's gone.
> You'll never find her. You'll
> fall in love again and she'll
> fall in love again, but
> you'll never be happy.
>
> MIKE
> I'll find her.

The two lovers are zapped back to Earth, living under very different circumstances. Annie, now known as Ally, is born to an upwardly mobile middle class family – soon to be wealthy -- and Mike, now known as Elmo, is delivered to an impoverished single mother. The former lovers move through their new lives on Earth without knowledge of each other. Elmo becomes a footloose wanderer with a bent toward music, and Ally is destined to become the head of her father's toy company. She has multiple boyfriends (of which I played one in passing, on the Columbia University campus), but none of those relationships work out.

Figure 2.1 Made in Heaven - Mike meets Annie in Heaven.
Credit: Warner Brothers/Lorimar Motion Pictures.

Figure 2.2 Made in Heaven – Elmo meets Ally on a New York City street.
Credit: Warner Brothers/Lorimar Motion Pictures.

Here's the issue. In Heaven they had the deep desire to be together, but when they are reborn as infants on earth they have no inkling of each other, or their need to be together. Nothing.

Each lives their separate lives, taking us through various adventures and misadventures in the story's second act. The second act is the crucial

marathon that covers the most screenplay pages and develops the plot and obstacles to the character's desires. But these **wants** were scarce in the second act. Granted, as an attempt to reignite the character's want, there's a brief encounter when Emmett appears to Elmo while he's hitchhiking to let him know that time is running out. But Elmo doesn't comprehend or accept what Emmett tells him, so the encounter is more for the audience's benefit than for Elmo's. "I care about you, Elmo. I want you to get the girl." But what girl? Elmo has no idea what Emmett is talking about. When he finally gets a ride, the driver asks him, "Where you headed?"

Elmo replies, "I don't know." Wrong answer.

Ultimately, Elmo and Ally wander through the script until they eventually land within each other's proximity on the streets of New York City (actually Atlanta disguised as Manhattan). If they knew that they were on a mission to find their other half, the story would have been more compelling.

Toward the end of the film, Ally and Elmo's lives still haven't crossed, but they are on the same New York City street. Ally has just received a marriage proposal from Lyman (get it, Lie Man?) who claims to love her, but it's clear she isn't in love with him. Later she runs into an ex-boyfriend shopping with his new wife, Pam, at Bloomingdales. Ally feels crushed and decides to walk rather than take her chauffeured limousine.

Elmo, who has been a down-on-his-luck musician, celebrates his 30th birthday with friends, toasting his first recording contract. But time has run out. He and Ally are both 30 years old, the deadline that Emmett set for them. But they're both walking the same street by coincidence – though coincidence isn't usually a good thing in stories:

```
EXT. STREET

Elmo is halfway through the intersection when
it happens. A car runs the light and hits him.
He is thrown up on the sidewalk and lays there
very still. His eyes are closed. As we MOVE IN
ON his face, the SCREEN GETS DARKER AND DARKER
UNTIL IT'S BLACK. And then the BLACKNESS
BEGINS TO MOVE. SLOW AT FIRST, THEN FASTER AND
FASTER. As we REACH MAXIMUM VELOCITY, CHUNKS
OF LIGHT HURTLE out of the darkness AT US.
Suddenly, we're IN A TUNNEL OF COLORED WHITE
LIGHT, going EVEN FASTER than we were in the
darkness. And then we STOP. In a WHITE ROOM.
Elmo is standing in the middle of it. And he's
naked.
```

 EMMETT (O.S.)
 Hello, Elmo.

Elmo turns around. Emmett, in his blue
coveralls and flannel shirt, is coming toward
him.

 ELMO
 Where am I? What happened?

 EMMETT
 You were hit by a car. But
 you're gonna be all right. She
 found you.

 ELMO
 I don't understand. What do
 you mean?

 EMMETT
 I love you, Elmo.

INT. HOSPITAL ROOM - EVENING

The "ELVIRA MADIGAN" THEME FADES IN. Ally is
sitting in the shadows at the foot of the bed
watching Elmo sleep. It's as if she's trying to
remember where she saw his face before.

After a long time she gets up and brushes a damp
curl off his forehead. She goes to the window
and stares out. The rain has stopped. In the last
light of day, a rainbow arcs over the city. She
sighs and goes to the edge of the bed. Elmo is
still sleeping peacefully. She takes his hand.

Life is what happens while you're making other
plans.

 FADE OUT

During the editing process, we eventually added quick flashbacks, sto-
len from scenes of Annie and Mike making love in Heaven. These were

designed to telegraph a subliminal memory and a desire for something lost to the past. But I'm not sure it was enough. Also, the director, Alan Rudolph, smartly allowed Elmo and Ally to glimpse each other in passing on the New York street, a trigger moment for a flashback that was not in the script. He even introduced a beautifully choreographed **oner** where Ally approaches the unconscious Elmo as he lies on the sidewalk after being hit by a car (driven by Ric Ocasek of *The Cars*) before being transported by ambulance to the hospital where doctors work to revive him.

 Oners, or a scene shot in a single take, still require edit-like manipulation to succeed. In order to sustain interest and tell the story, oners require the introduction of well timed beats, whether in performance, music, sound, camera position or other factors. Though generally not as commercially viable as the Eisensteinian montage approach to editing, some excellent films have come out of the single shot, long take approach, such as Hitchcock's *Rope* (1948). Andrei Tarkovsky's great works, such as *Stalker* (1979), present a sort of anti-Eisenstein approach. Unlike his countryman who believed in the value of fragmenting a scene into basic, often neutral, parts to achieve a riveting whole, Tarkovsky's approach to time and editing was leisurely, slow paced and naturalistic, allowing the camera to linger on shots for minutes at a time.

The ending was changed many times, including shooting additional scenes. Eventually, the car hit, the stunning single take on the New York City street, the tense ambulance ride, and the hospital scene where doctors fight to save Elmo were all cut out of the movie. One sensed that they had been manufactured to create a bit of conflict (drama), but these were not essential to the story. It was decided to end on Elmo and Ally as they discover each other amid Manhattan traffic. The goal has been reached – they found each other -- and the movie is over.

The director's unique vision and the picaresque quality that mirrored the wandering lifestyles of the late Sixties and early Seventies, made the film a favorite of some. To those the film is a heartfelt examination of the wandering life and the circuitous paths our lives take, with the hopeful message that wanderers eventually find their way -- or each other. But that might be better suited to a novel or short story rather than a 136-page script that needs dramatic action. Failing that, it failed at the box office.

This illustrates the importance for writers to establish a strong need in their characters. And to continue to reinforce that need throughout the

course of the screenplay. Establish a goal and make sure it's strong enough for your hero to risk everything to attain it. In the case of *Made in Heaven*, there was a strong need, but it was forgotten when the characters returned to Earth. There were some obstacles in their paths but these were often tangential. The conflicts were manufactured to add dramatic tension, but with only occasional reference to the central desire.

How to Help Your Characters Succeed

Writers will often tell you that they imagine a particular actor when envisioning a character for their stories. In other cases, characters grow out of a mélange of friends, acquaintances, co-workers who have crossed the writer's path. The great writer Ben Hecht (*Miracle in the Rain, Notorious, Scarface*) would often say in story meetings that he once knew someone who fit that character and from whom he could borrow traits and dialogue. Steven Zaillian (*Schindler's List, The Irishman*) observed that he reads "scripts all the time where the writer isn't exactly sure who the character is. They're experimenting with, 'Okay, what does the character..? Gets up in the morning...What does the character do?' They're starting at the very beginning of the day and as far back into the character's life as they need to go in order to understand the character.[1]"

Having a star in mind when writing a screenplay is a common and sometimes useful approach to character development. On the other hand, in actual practice, stars come with more aspects than might be obvious on the page. Their quirks, charms, reputations and idiosyncrasies influence their character on screen. They have a particular voice, which makes them unique. Just as a popular singer, such as Rihanna Lana Del Rey or Bruce Springsteen have a particular tone and cadence that is only theirs.

I discovered this when re-cutting a film with Jack Nicholson (which is discussed further in *The Healthy Edit*). The first cut missed some of Nicholson's wild and impassioned style. The jumping around, scrambling his hair with his hands, and shouting heavenward was mainly left out of the first cut. Though smooth and well constructed, the cut lacked the vibrancy that made Nicholson a star. By searching through the footage (with Nicholson's help on days when he visited the editing room), it was possible to build scenes that suited the audience's expectations of this actor.

If you're going to use a well-known performer as a guide to your character keep in mind that there's more than action and surface personality that build this character. There's tone, physical movement, appearance, back story, reputation, energy and other less easy to define elements. In establishing this, the screenwriter can use these traits as a model for developing the hero.

In a different case, Jack Nicholson was offered the lead in *Mosquito Coast* (1986), a potentially excellent match for the script's eccentric character, Allie Fox. Fox is a brilliant inventor who, having acquired a homestead (referred to as Jeronimo in the film) in a village along the river near Belize City, moves his family there and eventually goes berserk. One can easily imagine Nicholson in this part. For various reasons, he turned down the offer, including, some say, because he'd miss seeing his dear Lakers shoot hoops in L.A.

The offer rebounded over to another popular star of the time who had charmed audiences in the roles of Han Solo and Indiana Jones. Harrison Ford was known for such megahits as *Star Wars* (1977) and *Raiders of the Lost Ark* (1981) where his magnetic personality made him a strong and engaging hero. Audiences were accustomed to rooting for Ford and being with his confident yet vulnerable warmth. In this case, the audiences did not like Ford's craziness along with the character's obsessive egotism and nastiness. Consequently, the movie failed on multiple counts, including on the decision to alter the story's point-of-view.

Paul Schrader's script (and the novel by Paul Theroux on which the screenplay is based) established the right point-of-view. In the script the story was told through the eyes of the son, Charlie (River Phoenix), which supplied a buffer to his father's antics.

In this case, the final rewrite was ill conceived and, more likely, the film could have benefited from the screenwriter's original construction.

The original script begins in the farmhouse of the Fox family:

```
INT. FOX HOUSE - BEDROOM

The bedroom door opens and CHARLIE enters. He's
fourteen years old, and a fine looking boy. He
strides across the room grabbing a desk chair
which he carries to the far wall. He climbs up
on the chair to reach the top bookshelf. He
grabs hold of a large photo album.
```

Charlie flips through the pages of the photo album until he arrives at the smiling portrait of his father, Allie Fox. He speaks to himself:

```
                 CHARLIE
        What happened, Dad? What
        went wrong?
```

Wrong? It's an intriguing question and lets us know that there's a secret we need to decipher. As the first scenes unfold we learn about Allie through the eyes of his son.

Charlie speaks softly to himself.

> CHARLIE
> You were the best and worst of
> Fathers. You could be a bully, but
> You could also make us laugh.
> You took us on the adventures of
> our lives, but it cost you, yours.

Charlie looks up slowly at the CAMERA. The
CAMERA TRACKS imperceptibly toward him.

> CHARLIE (V.O.)
> My father was an inventor.

He breaks eye contract with the camera and
smiles to himself.

> CHARLIE (V.O.)
> (continuing)
> Once he invented an electric mop.

The scene then flashes back to Charlie's father struggling with a large
machine that flip-flops across the floor. His kids are mesmerized by the
bizarre sight and his mother laughs.

This humorous moment gives us some empathy for the father, a clever
but difficult idealist. Charlie continues to narrate as his mother (Helen
Mirren) tries out the mop.

> CHARLIE (V.O.)
> Father said that there was danger
> in all great inventions.

Mother is unable to control the machine which
lashes about wildly.

> CHARLIE (V.O.)
> (continuing)
> He saw things differently than
> other people and I loved that
> about him.

Since his son loves him, we can too. And Charlie loves his father because
he's different and hopeful. But these scenes, and several after them, were
left out of the final film. Only much later in the film, on the boat ride to

the village, does the subject of the electric mop appear. It is referred to in a conversation between Charlie and a missionary's daughter, Emily (Martha Plimpton), whom he meets on the boat.

"So, what's your old man do?" Emily asks.

Charlie: "My father's an inventor. He invented this mechanical mop, sorta dance around with it. It works all by itself. You'd have to see it."
Emily: "Weird."
Charlie: "My father's a genius."

We're given no image of the amusing moment of the flip-flopping mop – the script's flashback is left out – so it becomes a tell-rather-than-show moment, arriving too late to defuse the opinion we've already formed about Charlie's father.

In the final release version, the film opens with a shot of the Fox's pickup truck moving through the countryside with Charlie's voice over: "My father was an inventor. A genius with anything mechanical. Nine patents. Six pending. He dropped out of Harvard to get an education, he said." This cuts to the interior of the pickup truck and Charlie's close up. "I grew up with the belief that the world belonged to him and everything he said was true."

This then cuts to Harrison Ford at the wheel, driving. He speaks, "Look around you. How did America get this way? Land of promise. Land of opportunity. Give us the wretched refuse of your teeming shores. Have a Coke, watch TV…"

Charlie: "Have a nice day."
Allie: "Go on welfare. Get free money. Turn to crime. Crime pays in this country."

Charlie laughs. Off camera Allie continues: "Why do they put up with it? Why do they keep coming?" On Allie: "Look around you, Charlie. This place is a toilet."

This cuts to a wide shot of the truck moving toward us down the town's street surrounded by ad signs and fast food businesses. Cut to:

Interior hardware store. Allie enters and continues his rant. The shop owner sighs, clearly he's heard Allie's complaints before.

Allie to the clerk: "I want an 8-foot length of rubber seal with foam backing." After the shopkeeper finds the rubber seal, Allie hands it back because he realizes it was made in Japan. He wants something made in America. The camera tracks back with him as he leaves the shop. "Okay, we'll get it someplace else. This is not the only place in town. Good-bye… or maybe I should have said, 'Sayonara.'" A most unlikable character.

Figure 2.3 Mosquito Coast – Allie Fox in the hardware store.
Credit: Warner Brothers.

Allie's vitriol continues into the next scene as he rummages through a junkyard, finding the elements to build a portable, non-electrical refrigerator, a cooling system which he calls Fat Boy, for his farmer neighbor, Doc, who doesn't appreciate his efforts. Allie freezes a glass of water to prove it. But the farmer doesn't understand its advantage. "Ice is civilization," says Allie. The farmer is not impressed. Allie drives away with the rejected refrigerator in tow.

Afterwards, Allie shows his son the sad state of the migrant worker's shack. He explains that they have come from the jungle for a better life in New England, but Ford despises that life. "They trade green trees for this room. ... It would take courage to go there."

"Go where?"
"The jungle." His decision is made.

Without the script's opening scenes that depicted Ford as a caring family man bonding with his kids, the character becomes unsympathetic. And the casting meant that the protagonist (Ford) would play against type rather than using an actor (e.g. Nicholson) who could better mirror Allie Fox's erratic and aggressive personality in an engaging way.

As most writers know, we learn about characters by what they do, what they say about themselves and by what other characters say about them. In the script's case, the son's perspective modifies the obsessive and fiercely judgemental aspects of his father. We see him as an engaged family man who is also an amusing and dedicated inventor with daring ideas. An inventor whose genius eventually undoes him.

To accomplish this, Ford's character needed to start off likeable and then descend, but that trajectory didn't materialize. In a *Collider* review, Liam Gaughan declared that Ford had "shed his likeable persona to play an unhinged villain" and the condescending nature of Fox's lectures detracted from Ford's otherwise engaging personality. "Even before his mania escalates, Fox is a repellent character.[2]"

It's interesting to note that the book was remade into a 2021 television series, starring the author's nephew Justin Theroux (*Below Utopia, Mulholland Drive, Joker*). In it the screenwriters added an additional element of tension by giving the father more secrets and introducing government agents who pursue the Fox family. Allie Fox is not just an idealist fleeing from materialistic conformity with the hope of building a utopian community, as in the original, but also a fugitive from the police. Eventually they make it to the Mosquito Coast where other calamity follows.

In considering this example, we discover the risk of writing a script with an unsympathetic protagonist. The hero or heroine doesn't need to be perfect, but he or she should have likeable qualities, aspects that we can identify with in ourselves. Or our ideal selves. As Blake Snyder pointed out in *Save the Cat!*, "Liking the person we go on a journey with is the single most important element drawing us into the story.[3]" In the case of *Mosquito Coast*, the screenwriter understood this and crafted a sympathetic character in the character of the son, Charlie, but the reality of Hollywood set in and overrode it. Stars matter and here a famous adult actor was given more play than the lesser known teenage actor.

Figure 2.4 Mosquito Coast – Emily and Charlie meet on the boat to Jeronimo.
Credit: Warner Brothers.

The Netflix film, *The Gray Man* (2022), reflects the advantage of creating a likeable character, even in one that does potentially reprehensible actions. The film begins with a prison meeting between an incarcerated murderer (Ryan Gosling) and a CIA recruiter. The CIA agent arranges for Gosling's release from prison in order to use his prodigious killing skills as a CIA operative designated as Six. Despite Six's sketchy history and job that involves murder and mayhem, we come to like him because he has his own moral code. In his first assignment, he refuses to pull the trigger on a target because of the collateral deaths it would cause, specifically to a child standing beside his intended victim. As the story develops, Six risks his life to protect the young niece (Julia Butters) of a loyal friend, eventually committing to be her protector when her uncle (Billy Bob Thorton) is killed. Because the writers were careful to show Six's caring and altruistic side, we are more inclined to root for him in spite of his other serious flaws.

Following this prescription requires the writer to find believable ways of engendering sympathy so it doesn't feel contrived, as some claimed was the case in the collateral death scene. *Made in Heaven*, despite other shortcomings, organically incorporated this approach when the main character, Mike, comes upon a family trapped inside a car that has gone off a bridge and into the water. Mike jumps in and saves them, but ends up sinking with the car. He dies, but this good deed takes him to heaven and into our hearts.

What are the skills and knowledge that writers and editors bring to the filmmaking process that allow them to conjure films like those in our initial examples? How do writers spin stories from the raw materials of memories and imagination? How do editors take the material in front of them and weave it into a successful tapestry? In the next chapters we will look at the tools of writers and film editors.

Notes

1 Austin Film Festival. *On Story: Screenwriters and Their Craft*. Edited by Barbara Morgan and Maya Perez.

2 Gaughan, Liam. "Why 'The Mosquito Coast' was Harrison Ford's Riskiest Performance. " *Collider*. 30 Apr. 2021. collider.com/the-mosquito-coast-harrison-ford-performance/

3 Snyder, Blake. *Save the Cat!* Michael Wiese Productions. Studio City, 2005. p. xv.

3

THE WELL OF COVERAGE

This chapter offers a look at how production footage ("the dailies") grows out of the script. It discusses the different types of coverage and latest protocol for digital dailies. The use of multiple cameras, grouped clips, project organization, and improvised coverage is discussed.

The Dailies

In the collegial way that directors and editors become close and share stories in the editing room, I once asked a director what was the one thing he'd want with him on a desert island. He replied: "My dailies."

Dailies are the essence of filmmaking, and there are enough possibilities in them to keep a marooned director or, for that matter, editor engaged for all of time. It's important for writers to understand this basic process of how a movie grows out of their script.

Most people who are aware of the term know that dailies, or rushes as they're often referred to in the UK, consist of the footage that was shot the previous day and delivered to the editing room the next morning. That was when everything originated on film. Even the terms **film** and **footage**, which are still used today in the digital era, refer to artifacts from the celluloid days when film was a perforated strip of plastic, generally 16 or 35 millimeters wide, with 40 images every foot in 16mm and 16 images every foot in 35mm, etched into it by a photochemical process.

Footage refers to the resulting rolls of film measured in feet and frames. In 35mm, the film runs at 90 feet per minute and, in 16mm, 36 feet per minute. Because it takes time to develop and print the dailies they are delivered to the film laboratory at the end of the day's shooting, processed overnight, and delivered to the editing room the next morning.

 DOI: 10.4324/9781003161578-4

Today, with digital file-based production, dailies can arrive instantly in the editing room, since they require no processing time. The footage is captured in the camera, transferred to a hard drive or cloud-based medium, and then sent to the editor. This is the **coverage** that the editor will work with. Those dailies cover every shot and nuance of character and dialogue stated implicitly or explicitly in the shooting script and envisioned by the director and cinematographer.

For Editors: Coverage is your friend, though sometimes even friends can overstay their welcome. Too much coverage can suggest an unfocused approach. Or it can leave the door open to experimentation. Either way, it's important to view all the coverage (the dailies) and discover an approach to each scene. Recently, there has been a trend toward shooting massive amounts of footage using multiple cameras. This amounts to hours of dailies each day. When movies were shot on film using single cameras, dailies often consisted of only a few rolls each day – each roll runs about 10 minutes – comprising approximately a half hour or so of useable material. Further, individual takes were circled on the camera reports to designate only those that should be printed and sent to the editing room. This took a discriminating eye. Now, with multiple cameras and digital media, coverage has mushroomed, and the editor is tasked with evaluating more material and making more decisions. Either way, it's important for the editor to become intimate with the footage and memorize the different set-ups so as to call upon them at will. What will guide an editor through all the footage? Read the script and you will answer the two most important questions: *what is the film about* and *who is it about?*

Coverage

What are those shots that make up the dailies, and how are they arrived at? The original script usually gives limited guidance as to what camera angles will be required to properly communicate the meaning of a scene. That's up to the director and the director of photography. Directors choose from an immense array of possibilities, capturing the scene from multiple angles with redundant action and dialogue. This allows for **continuity editing**. Each camera angle carries its own meaning. A **wide shot** may express

vastness or isolation, where a **close-up** may suggest intimacy or intensity. **Two-shots** can bring people together or, when in profile with the actors positioned at opposite edges of the frame, they can show alienation, conflict, or emotional distance. The selection of angles and their composition is one of the essential considerations that the director makes when covering a scene.

Continuity Editing: This technique depends on a variety of angles, each conveying redundant information in dialogue and action. The fact that the actors' lines and movements are captured from a variety of viewpoints allows the illusion that a scene is one continuous action when edited together. At the same time, it benefits from the meaning implied by the different angles. By matching actions, maintaining eyelines, and a handful of other principles, the filmmakers convince the audience that the story unfolding in front of them is one uninterrupted flow. In fact, it may be made up of thousands of cuts.

How does a director determine the necessary angles to cover the scene? To cover a scene with every possible angle would generally prove cumbersome, time consuming, and expensive. Only the coverage that best tells the story should be shot. In doing so, the director and cinematographer imagine how the shots will fit together in order to fulfill the needs of the script's characters. In that way, the shots become more than images, they become images bearing emotion.

Consequently, the director must conceptualize how the shots will be edited together. They are the surrogate editor, as the editor will later become the surrogate director. But this initial arrangement takes place in a cursory way. Even with elaborate storyboards or pre-visualizations, the true design (with few exceptions) won't become apparent until the editor takes hold of the footage. This is because the editor controls something that no one else in the filmmaking process has domain over – the selection, pace, and rhythm of the cuts.

There are many lists ranking what should have priority in the editing process – is it continuity or emotion or structure or eye trace or something else? The answer must inevitably be rhythm since finding the proper rhythm determines the resonance of the shots and performance and ultimately the emotion. Rhythm is meaning. Rhythm is emotion.

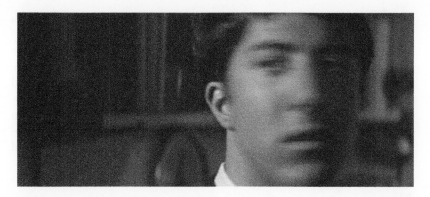

Figure 3.1 The Graduate – Ben's head spins.
Credit: United Artists.

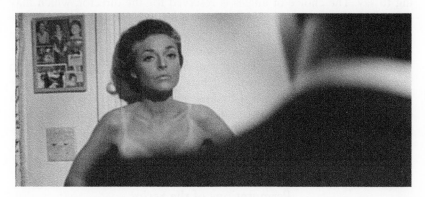

Figure 3.2 The Graduate – Mrs. Robinson enters naked.
Credit: United Artists.

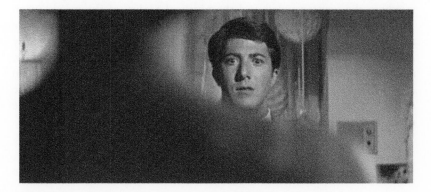

Figure 3.3 The Graduate – Ben's stunned look.
Credit: United Artists.

In the director's or cinematographer's creation of shots and the editor's subsequent selection of those shots, the rewriting process inevitably begins. In some cases, there may be many more set-ups than there are shots that make it into the final cut. A classic example comes from the seduction scene in *The Graduate* (1968), where editor Sam O'Steen used about a third of the angles that were shot. Ben's (Dustin Hoffman) memorable head spin when Mrs. Robinson (Ann Bancroft) enters the room naked was created by repeating his surprised turn multiple times. It supplanted many more direct and graphic images, including a full frontal shot of Bancroft naked, which was never used. In making this choice the editor brought subtlety to what the script described in a more blatant way.

It is generally advised that the writer not include camera angles in the script unless an angle is particularly illustrative of what the writer is trying to say. The choice of angles is reserved for the director, which may account for why so many writers seek to direct their own material. The practice of excluding camera angles from a script doesn't, however, mean that the writer should ignore the influence of camera angles.

Well-designed camera angles elicit an emotional response. Even though writers are not responsible for shot lists or determining coverage, there are times when a writer will include a judiciously placed reference to a camera angle in the script. This is best when the angle helps suggest a feeling, such as a "smash cut to her shocked face" or an "insert of his fidgeting hands."

Permutations of the Script

The dailies, and those angles that make up the coverage, are the crucial first step of the translation – or abstraction – from the screenplay. This is where the written word and the physical reality of the movie meet. The original script which, when annotated with scene numbers, became the **shooting script** is transformed into a new incarnation, thoroughly marked up with lines, squiggles, numbers, and letters signifying where each shot fits into the overall scene. This newly created artifact, known as the **lined script**, contains a myriad of detailed annotations from the script supervisor. It serves as a map to guide the editor through the morass of unorganized material. Already, the script has evolved.

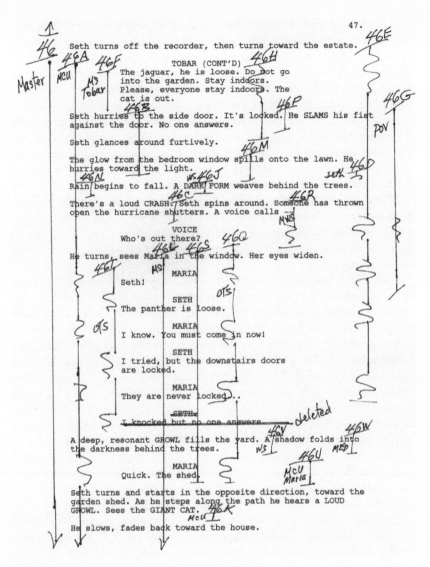

Figure 3.4 The lined script.

Organization

It is hard for people to watch dailies. Not just because dailies can be long, repetitive exercises that can try anyone's patience, except for perhaps the editor's and director's, but because, unless you directed the scene, you're probably not familiar with how all the varied pieces are supposed to fit together. Dailies are shot out of order, in the sense that expediency rather

than story structure becomes the driving force on a set. If the set isn't fully lit yet or the dolly tracks haven't been laid, why wait to shoot the wide shot when you can capture the close-up coverage in the meantime? If an actor arrives late on set, shoot the other actor or insert shots or some establishing shots. Either way, at the end of a day's shooting, the camera's media files contain a massive amount of disordered footage.

In my editing room, the assistant editor is tasked with organizing the dailies in their respective Avid bins according to the scene numbers and the order established by the lined script. In a sense, assistant editors are the first ones to begin the editing process, since establishing story order is the first step toward developing a creative cut.

When examining dailies, studio executives, producers, and bond company agents expect that they're watching a movie when in fact they're watching disjointed parts of something that doesn't yet exist. So, it's essential to make the dailies as clear as possible by ordering them based on story order.

Something else also occurs at this stage. Away from the madding crowd of the set, the editor sees the film for what it is, its glories and its faults, the aspects that don't work, and the ones that thrill in their sublime execution. This can be minuscule and subtle or gross and earth-shaking.

When editors encounter missing pieces, they need to tell themselves a tale that helps to fill in the gaps of the story, structure, or coverage, allowing them to complete the puzzle. What the editor imagines might be the bridge of one line of dialogue to another or a complete reworking of the entire scene. Now the editor is hunting for something in the dailies that will satisfy a need. A need that was created by the film's original intent but hidden at times in the forest of footage. The dailies have taken on a new dimension. What was passed over previously becomes significant and necessary, and we return again and again to the dailies in search of a solution. An action or image that once meant nothing now means everything.

As the film's final guardian, the editor will find ways to fulfill every line of dialogue, enhance every action, coax every nuance. On the other hand, they will also bring a subjective, creative view. The editor will discover within the footage unexpected gems. In some cases, the ending will change, characters will grow more prominent or recede into the background, the beginning will start differently, a new theme will emerge, the pace will increase or grow more leisurely, the story will find a new trajectory. All these aspects and more appear in the final rewrite known as editing.

Even though the writer can't anticipate all the nuances that occur during filming, or the subtle choices that are made in post production, they know that the more focused the story and the more detailed the characters, the greater the opportunity to fully realize the film at this stage of the process. Editing can make a poorly written film better, but it will never make a poorly written film great. That's up to the screenwriter.

Colored Pages: The Writers Guild of America (WGA) has established a guideline for the sequence in which revision pages are incorporated into a shooting script. Though individual productions are free to develop their own scheme, this is the WGA's recommended arrangement:

White draft (original).
Blue revision.
Pink revision.
Yellow revision.
Green revision.
Goldenrod revision.
Buff revision.
Salmon revision.
Cherry revision.
Second blue revision.
Second pink revision.
Second yellow revision.
Second green revision.
Second goldenrod revision.
Second buff revision.
Second salmon revision.
Second cherry revision.

Keep in mind that screenwriting is not an exact science. It's an art, and the process involves a lot of revision. As Hemingway famously said, "The first draft of anything is shit." When it comes to evoking something as complex and ethereal as human existence, it's no wonder that screenplays go through draft after draft before arriving at the finish line. It's nearly impossible to get everything right in the first few drafts of a script. Or to envision all the changes that will occur during production and post production. In this regard, writers can take advantage of a film editor's insights to help their scripts advance to a higher level.

The next chapters will provide an insight into that process and instill in writers a way to approach the blank page with the mindset of the final product.

4

THE SCENE AND AN APPROACH TO DAILIES

The editor's approach to dailies is seen as one of the crucial elements of filmmaking. How the editor deals with coverage determines the trajectory of every scene and ultimately the entire film. This chapter offers insights to writers into ways to start a film and how to sustain interest through well-considered scenes.

A Word about Scenes

Scenes are the constituent parts of movies. Within scenes are all the individual actions and lines of dialogue that lead up to a memorable scene. Maya Angelou once observed, "I've learned that people will forget what you said, people will forget what you did, but people will never forget how you made them feel." Films are like that too. The best ones contain memorable moments, scenes that make us feel.

Scenes are memorable when they capture the essence of the film's characters and themes. Most cinephiles know the great scenes, the ones that somehow transcend the medium to mean something more, something universal, in the way that classic stories resonate in the collective consciousness of humanity throughout time.

Think of the many memorable scenes (and their accompanying dialogue) in your favorite films. Here are a few to consider:

- *Casablanca* is full of great scenes, starting with the moment when Rick's (Humphrey Bogart) old flame, Ilsa (Ingrid Bergman), walks into his nightclub, recognizes the piano player, Sam (Dooley Wilson), and asks him to play "As Time Goes By." Initially Sam refuses because the broken-hearted Rick has forbidden him from ever playing that song. But, when Sam finally relents, Rick hears the song and reprimands him for playing it, only to look up and see Ilsa. Later, Rick

 DOI: 10.4324/9781003161578-5

reminisces, "Of all the gin joints, in all the towns, in all the world, she walks into mine."

- *Star Wars* is full of memorable scenes, but the most stirring is the reveal when Luke Skywalker accuses Darth Vader of having killed his father. Vader's reply, "No, I *am* your father," has become a classic quote in popular culture, though the line is often slightly misquoted as, "Luke, I am your father," probably because the actual line doesn't make as much sense as a standalone.
- In *The Godfather*, everyone remembers the horse's head in the bed scene, preceded by the scene where Don Corleone (Marlon Brando) promises, "I'll make him an offer he can't refuse."
- *Chinatown* also has a memorable scene of threat. It's the scene at the reservoir where the hoodlum played by the director, Roman Polanski, cuts the nose of Jake (Jack Nicholson). "You know what we do to nosey people?" he asks.
- In *Field of Dreams*, there is the moment where farmer Ray (Kevin Costner) realizes the fulfillment of his dream as a team of baseball legends emerge from his cornfield. The scene was preceded by a vision accompanied by the famous line, "Build it and they will come."
- And what about the mad as a hatter General Jack Ripper (Sterling Hayden) with a cigar jutting from his mouth as he warns against the communist conspiracy involving his "precious bodily fluids," after sending a B-52 to bomb Russia in *Dr. Strangelove*?
- The shower scene in *Psycho* is one of the classic horror scenes of all time. And not a word is spoken, unless you count screams.
- Another great scene is the seduction scene in *The Graduate* and the emblematic image of Benjamin (Dustin Hoffman) framed in the arch of Mrs. Robinson's (Ann Bancroft) calves.
- The bullet time sequence in *The Matrix* (1999) showcases innovative visual effects to reveal the ultrahuman powers of the film's protagonist, Neo (Keanu Reeves). It's accompanied by the memorable image of the actor defying gravity as he bends backward to dodge bullets sailing past him in slow motion.

If you can come up with one memorable scene, you'll change the course of movie history.

Writing the Scene

How we approach issues and events often determines their outcomes. Do you sneak up on a goal or do you pounce on it? Having an approach is an active pursuit. It involves placing yourself in the right position to meet a challenge head on. Writers and editors encounter two basic issues in this regard – the approach to the task itself and the approach to the material.

The question is often where and how to begin? Once you have committed to a direction, things tend to fall into place. With editors, it involves finding the right shot with which to open a scene or, for that matter, the entire film. This is not to say that everything from then on is easy or straightforward, but the work travels along a revealed path and within a clear context. The long-running series *Downton Abbey* (2010–2015) began with a simple shot of a telegraph key clicking out Morse code signals. Technology, progress, and communication became some of the guiding themes of the series. In this case, the telegraph key carries the message that the *Titanic*, carrying the heir to the Downton estate, has sunk. So begins all the complications inherent in that, propelling the series forward.

Finding and committing to an approach can become the main hurdles to overcome, since fear can accompany commitment. Is this good enough? What if it doesn't make sense? What if I head off in the wrong direction or mess up once the journey has begun? What if I run out of ideas? What will others think?

These and a slew of other concerns can impede a successful start and hinder a smooth journey forth. But that's why rewriting exists. Few endeavors, whether in life or art, are perfect, and it's important to know that opportunities to change direction exist. Of course, the more experience and understanding one brings into the process, the more likely one is to avoid trial-and-error type problems and build a solid foundation from the start.

First, let's examine the issue of the task itself. How do you begin, and how do you proceed?

First Steps

In writing, the first pass may contain remnants of the process itself, the priming of the pump, as it were. Often, we don't start deep enough into a scene, as in the extreme example of *Lost Horizon*, where not only scenes but entire reels could be excised. In most cases, however, it may be a matter of eliminating just the first several lines or a single scene.

Here's the opening of a scene from the Sundance selection *Horseplayer* (1990), a film about Bud (Brad Dourif), an ex-con struggling to get his life back together while being preyed upon by an artist and his girlfriend who have conned him out of some of his money. In this scene, Randi (Sammi Davis), the girlfriend, has been tasked with the mission of convincing Bud, whom she had previously seduced, to give over some more of his hard-won money.

```
EXT. L.A. RIVER - DAY

Bud pulls the Rambler to a stop on the bluff
above the river.
```

```
INT. RAMBLER - CONTINUOUS
```

Bud cuts the engine. Randi sits beside him;
she looks at Bud - rather nervously - as he
proceeds to stare silently at the river.

> RANDI
> So. You come here to
> think, I guess.

Bud nods.

> RANDI
> What do you think about?

Bud gives the question a fair amount of
thought.

> BUD
> I don't know. I really don't know.

> RANDI
> Well, that's cool. Just sort
> of zone out, huh?

> BUD
> (earnestly)
> I guess that must be it.

Randi laughs.

> BUD
> What?

> RANDI
> Nothing, you're just - funny,
> that's all.

In screen time, this opening dialogue felt long and uninteresting. It seemed
more like a window into the writer's process than a scene. It was the
windup before a pitch, the kind of noodling that writers do before finding
the best place to begin. This was the work of a very talented writer–director,
Kurt Voss. Yet it's an issue all writers confront – where to begin.

After a long beat the dialogue continues, eventually finding the essence
of the scene.

> RANDI
> Look, I want to ask you
> something.

39

> BUD
> Anything.

> RANDI
> I need more money.

> BUD
> How much?

> RANDI
> Two thousand dollars.

> BUD
> Huh. I don't have it.

Randi almost seems relieved to hear it.

> RANDI
> Well, that's okay -

> BUD
> But I can get it.

The scene continues from here, but at this point we're engaged. Eventually, Bud promises to get the money for Randi, and she leans over and gives him a kiss as a sort of reward. During the editing process it became clear that the dialogue in the first part wasn't necessary. Why not start with the crux of the scene, "I want to ask you something," and build from there? In order to do it, however, it was necessary to find a smooth transition that allowed the dialogue to begin deeper into the event.

This scene was preceded by a scene that introduced the scheming between the artist, Matthew (Michael Harris), and Randi.

> MATTHEW
> … do try to get some more cash
> out of him. Shoot for two grand.

> RANDI
> Two grand!

> MATTHEW
> Work him.

Matthew laughs.

40

Figure 4.1 Horseplayer – Randi and Matthew kiss.
Credit: Greycat Films.

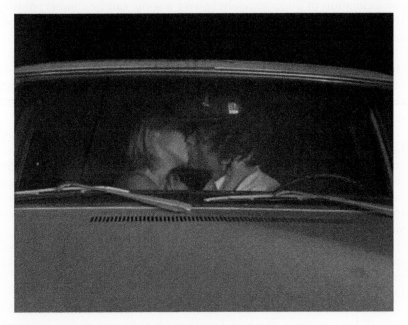

Figure 4.2 Horseplayer – Randi and Bud kiss.
Credit: Greycat Films.

 MATTHEW
 After all, I NEVER said you
 weren't an artist, too.

 Randi can't help but smile. Matthew leans
 forward, puts his arms around her and kisses
 her full on the mouth.

The fact that Matthew has given Randi a reward – the kiss on the lips – supplied the idea for a different approach and a strong transition. Why not steal the kiss between Bud and Randi, which originally occurred at the end of the next scene, and use it as an associative transition, a **match cut**, from the previous scene? The only maneuver that needed to be made in order to achieve this was to reverse the action in the last shot of their scene. Instead of their lips moving toward each other for a kiss, they would start with a kiss and then separate. At that point, I cut to another angle which allowed the dialogue to begin: "I want to ask you something." Going from one kiss to the other made for an elegant transition and supplied additional meaning and subtext to the scene. We'll talk more about types of transitions later on.

The First Draft

Professional screenwriters and editors are often up against deadlines, and the inclination to linger excessively over a scene can be counterproductive. This is one of the benefits of deadlines. They spur the artist onward, requiring them to maintain the flow of the work.

Flow is essential. It informs rhythm and spontaneity and all those good things that foster creation. Keep writing, even if it doesn't feel right. Push forward. Don't look back. You can return to the scene at a later time and re-evaluate. When you do, you'll be approaching it with fresh eyes, and issues that once seemed insurmountable will take on new clarity.

As is widely acknowledged by writers, confronting the blank page can be a harrowing experience. For film editors, meeting the mass of footage, sometimes unrestrained and seemingly limitless, can feel daunting. Writers may obsess for days over how to dive into a project. Editors comb through take after take to find the right image with which to enter a scene. Where to begin? What's the first sentence? What's the first image? These decisions will determine the approach to all that will follow.

Once there, various issues can impede the creative writing process, from self-doubt to the convenient desire to make a sandwich, take out the garbage or do the dishes. No wonder some writer's homes are so neat. It takes a lot to stay put and keep writing.

Initially, the writer and editor should follow their intuition about the project. For the writer, that initial spark needs to be nurtured and allowed

to grow. For editors, inspired by the images and performances, ideas can come and carry them along in their path. Some ideas will solve production problems, others will add new layers, and others will envision something entirely new.

For both writer and editor, the work doesn't need to be perfect at this stage. Perfection – or as near as one can get – will be found in subsequent drafts and iterations. At first, the trick is to not get in the way. Don't judge too harshly, don't overthink. And ultimately, the screenplay you're writing or the film you're editing may surprise you as it takes on a life of its own and eventually reveals what it is truly about. It's hard to get to that point if you are constantly stopping yourself, self-correcting, stepping out of the flow.

But, whether the initial pass is good or bad, moving forward connects you to the larger rhythm of the work. It circumvents the inner critic and gives free rein to an unfettered imagination. Keep going, try not to pause. A lot of it will be lousy. Doesn't matter, keep going. Later, the critical faculties will swoop in to clean it up. Occasionally, something stunning and unexpected crawls out from under the falling debris of words and film clips. But, without advancing in this way, nothing happens. And deadlines lurk.

Schedules, budgetary limits, and even restrictions on tools can have a beneficial effect. The painter Pablo Picasso once observed that "forcing yourself to use restricted means is the sort of restraint that liberates invention. It obliges you to make a kind of progress that you can't even imagine in advance."[1]

Keep at it. Roy Englert, the 99-year-old runner from Springfield, Virginia, was asked how he manages to keep up the pace at an advanced age. He advised, "Keep moving, keep moving, keep moving ... and have a little luck."[2]

In Chinese calligraphy, artists often speak of movement and flow as essential to maintaining spontaneity and completing the work. One can take inspiration from the masters of this art. Expert calligrapher Xue Longchun, from Hangzhou, put it this way:

> When I write, I may have a general grasp of the whole work in my mind, but I do not try to calculate every step or stroke. As I understand it, a lot of calligraphy is simply the result of completing the motions that your hand should trace. It's not important whether or not the form matches what you had imagined or what someone else has asked for. What's important is that you haven't missed any steps in those motions. It doesn't matter whether there is ink in a particular spot. What matters is whether you completed your motions, even just motions in the air.[3]

Figure 4.3 Calligraphy.
Credit: Public Domain Pictures.

Zhu Chengjun, who lives and works in Los Angeles and Beijing, concluded,

> Ultimately, you can't necessarily control things precisely. If you control precisely, if you completely follow what's in your mind and just execute that, then the work will feel too crafted. It's precisely because a work has a certain amount of spirit, because it has a certain amount of unpredictability, that it comes to appear rich and lively. If you create a work based purely on your mental plan, it will feel so constrained that is seems dead. That is not good artwork. So, I believe that to have a complete image in mind is not a good thing.[4]

Once, in recutting a film, I was struck by how precise the original editor's cut was. He had clearly thought out each move, followed all the principles of continuity editing – match action, maintain continuity, don't cross the 180° line, and so on – yet the film had a kind of dullness to it. It was too perfect. And flat. That's why I was there, to add some flaws, if you will. The case was that the editor hadn't taken any risks, hadn't gone with his gut. He was a fine editor, but, under the watchful eyes of the director, who insisted on leaning over his shoulder throughout the first pass, he felt constrained to follow the rules. In this editor's case, he was hesitant to make fast or sloppy edits because he had a reputation and knew he was

being watched. Any messy cut or misstep would have been registered by the director, who believed himself a capable editor as well.

This is one reason why it's best for writers and editors to initially put the work together on their own, so they can follow their own impulses and push forward in any spontaneous and immediate way they can.

Notes

1 Gilot, Françoise, and Carlton Lake. *Life with Picasso*. Doubleday, New York. 1964.
2 Minsberg, Talya. "These 90-Year-Old Runners Have Some Advice for You." *New York Times*. May 22, 2022.
3 The Huntington Library and Gardens. "A Garden of Words: The Calligraphy of Liu Fang Yuan." San Marino, CA. September 29 to December 13, 2021.
4 Ibid.

5

ANOTHER APPROACH

The chapter explores various ways to think about a scene, when an editor's or director's approach reveals another way to envision the script. Also discussed are obstacles that occur at the script level and can be overcome during post production in a way that speaks to writers.

The Gift of Memory and Its Limits

In my film class at USC, showing the original dailies from a theatrical feature is followed by a look at the final cut that was released in theaters. Students are often startled by how different the final version is from the dailies and, for that matter, from the original script.

One evening, while screening an example of professionally shot dailies, I was struck by a remark made by one of the students. Everyone had been asked to watch carefully as the different takes of a scene played out on the screen. They needed to pay attention to each set-up, notice how the coverage – the wide shots, medium shots, close-ups, two-shots, and so on – had been organized in story order rather than the random shooting order. This would help guide them when they were eventually called upon to describe how they would edit the scene.

Those scene elements involved a young man and woman exiting a taxi in a wide shot and climbing a long series of steps up to an apartment complex. Because the dailies were organized in story order, rather than shooting order, the taxi shot was placed first even though it was the last shot of the night.

The next shot showed a view down a corridor where the couple, chattering livelily, approach the camera and then turn left to enter another flight of stairs toward the young woman's apartment.

Then there was an angle from the top of the stairs looking back as they climb the steps toward the camera and then turn past the camera into a

DOI: 10.4324/9781003161578-6

two-shot at the door. At the door there was tighter coverage – two over-the-shoulder shots, one on him, one on her – where they speak and then kiss. And finally there was a last shot from below as he walks back down the steps toward the camera.

Most people, when called upon to say how they would edit the scene, describe it exactly in that order. At the door they have to make a decision whether to go back to the two-shot somewhere between all the close-up dialogue, but, other than that, it appears completely straightforward. Anyone, it would seem, could recite how the scene should be put together. Except this student.

On this particular occasion the student, when called upon to describe how he would cut the scene, found that his memory failed him. Even though he believed he'd paid careful attention and remembered all the elements, he'd forgotten several set-ups.

In describing how he would put the scene together, he left out two major components – the walk down the corridor and the angle where the couple walk up the steps and the camera pans to follow them to the apartment door. He also neglected to mention the final shot, the low angle as the young man leaves. At first it seemed that he hadn't followed the assignment, hadn't paid attention. He had left out three shots that were essential to the script because they contained dialogue and moved the characters forward. When he was reminded of the shots, he reacted, surprised. "I really was paying close attention, but I completely forgot," he said.

Then we viewed the completed version that had been released in thousands of theaters around the country. To everyone's surprise, it turned out that those three shots that he had forgotten were also missing from the final version. It was exactly as he had described.

It appeared as if the film's editor had also forgotten about some of those takes when constructing the scene. Of course, he hadn't but, in reviewing the scene, the editor realized that those elements were not necessary to tell the story. The dialogue that had occurred in the corridor had been salvaged from that shot and placed on the couple's backs as they climbed the stairs from the taxi to the landing that would normally take them to the corridor. The student's mind, in recalling the dailies from memory, had inadvertently edited the story by leaving out all the insignificant material. He saw the characters walking up the long flight of stairs and going directly to the apartment door where the dialogue and kiss occurred. It appeared that his mind had unconsciously edited the scene by neglecting to remember anything that unnecessarily complicated it.

Intuitively, his mind didn't care what was at the top of the first long flight of stairs and had spliced it to the stairs leading up to the front door, just as dreams create convenient spatial leaps.

This reordering is a common phenomenon that we all experience, whether we acknowledge it or not. We remember a wedding we went to and the flower girl who threw the rose petals down the aisle, but we may not remember what the bride's mother wore. Our memories work selectively, keeping what we find important, eliminating other items, and sometimes even rewriting the experience so a relative who left early appears to have been hanging around until the end.

Editors have the advantage of perceiving an actual object, the dailies. Writers start with the blank page. In viewing the dailies, editors discover what is necessary and what is superfluous. This is the best reason for organizing dailies in story order – it frees the mind from its sorting functions and allows it to think creatively, which opens a door to the unconscious manipulation of time and space.

For Editors: In the days when all dailies originated on film, the common ritual during the production day required everyone to meet up at some point, often around lunchtime, and gather in a projection room or, if on location, a converted parking structure, ballroom, or local movie theater and view the coverage from the previous day's shooting. The rare production today follows this process of gathering director and editor together to view dailies on a theater screen. According to Andy Jurgensen, the editor of *Licorice Pizza* (2022), director Paul Thomas Anderson preferred not only to screen dailies with Jurgensen but actually to print and sync celluloid dailies for projection on a theater screen. This mirrored the old school format of the 1970s, when *Licorice Pizza* takes place. In this case, the process carried through all the way to the release print – cutting the 35mm negative to conform with the final cut and then printing it and timing it photochemically.

Today, with the sophistication of **video village** and remote monitors that can be viewed during each take, combined with tight shooting schedules and even tighter budgets, this ritual rarely takes place. Still, someone needs to make sense of the dailies. Even if digital files will later be sent to director, producer, and studio exec who may not get around to screening them, the dailies need to be in viewable form. And for editors it's essential to work with well-organized dailies.

For writers, the practice of writing a scene or story and then revisiting it days later, perhaps by recounting it to a neutral party, or writing it down as best recollected, or asking someone to recite the story as it had

been told to them, can produce a similar effect. The mind, more often than not, finds the easiest, most essential, and direct path to the story.

To follow the path of least resistance is incorporated into the laws of physics. In editing, the path of least resistance involves removing pauses, superfluous action, and dialogue that doesn't contribute to character or clarity. Consider the *Horseplayer* example. Removing excess dialogue enriched the scene in many ways. Scenes work when everything that is not that scene has been cut away. In a genre like comedy, which our class exercise scene was based on, timing is essential. Comedies generally benefit from a lively, energetic pace, and anything that stands in the way, such as long walks up stairs or down corridors, should be removed.

In the early 1900s, a graduate student studying anthropology at Cambridge happened upon an experiment that revealed the failings and virtues of memory. Like our example with the dailies, Frederic Bartlett happened upon a story that had extraneous details, confusing ideas, and excessive information. The story was a Native American folktale called the "War of the Ghosts." It is reproduced in the box.

Bartlett used this story to test his theory of reconstructive memory and how events can be altered by a person's own schema.[1] He read the story to a group of subjects whom he asked to recount the tale 15 minutes after hearing it. Then he checked in with them days later and even weeks after that. In one case, he encountered one subject on the street two years later and asked to hear the story.

Upon recalling the story, the subjects left out most of the confusing or nonsensical elements (leveling) and added some new elements (confabulation) for clarity or interest. Story elements that failed to fit into the schemata of the listener were altered to create a better story. The subjects' minds, without knowing it, were editing the story to help it make sense. And to fit their own cultural experiences. Just like editors confronting a wide array of disparate material that constitutes the dailies.

For instance, here is one recollected version of the story, which is clearer and more streamlined:

> One day a young man was walking along the shore when a canoe carrying some of his friends appeared. They announced that they were going up river to join a battle. They asked the young man to help them and he agreed. Farther up the river they met the other warriors and engaged in a brutal fight. Many were killed. But his side was victorious. As they were leaving, the young man was shot with an arrow, but he managed to make it back to his home. He was celebrated for his heroic exploits and for helping to save his people, but eventually he died from his wound. The story of his bravery is still told to this day.

War of the Ghosts

One night two young men from Egulac went down to the river to hunt seals and while they were there it became foggy and calm. Then they heard war-cries, and they thought, *Maybe this is a war party*. They escaped to the shore and hid behind a log. Now canoes came up, and they heard the noise of paddles and saw one canoe coming up to them. There were five men in the canoe, and they said:

"What do you think? We wish to take you along. We are going up the river to make war on the people."
One of the young men said, "I have no arrow."
"Arrows are in the canoe," they said.
"I will not go along. I might be killed. My relatives do not know where I have gone. But you," he said, turning to the other, "may go with them."

So one of the young men went, but the other returned home.

And the warriors went on up the river to a town on the other side of Kalama. The people came down to the water and they began to fight, and many were killed. But presently the young man heard one of the warriors, "Quick, let us go home, that Indian has been hit." Now he thought: "Oh, they are ghosts." He did not feel sick, but they said he had been shot.

So the canoes went back to Egulac and the young man went ashore to his house and made a fire. And he told everybody and said, "Behold I accompanied the ghosts and we went to fight. Many of our fellows were killed and many of those who attacked us were killed. They said I was hit, and I did not feel sick."

He told it all, and then he became quiet. When the sun rose he fell down. Something black came out of his mouth. His face became contorted. The people jumped up and cried.

He was dead.

This final rewrite of the story shows how the mind, which is ultimately the recipient of the stories we tell, also has a stake in processing those stories in order to align them with what we know about character, plot, pacing, and emotion. In Bartlett's experiment, elements that didn't follow the throughline were rejected, and elements that helped add clarity were

added. Writers can take advantage of this natural editing process that memory provides.

Beyond "Cut"

On set, calling "Cut!" signals the end of the scene and implies the end of recording. But experienced cinematographers know to wait several seconds, some as much as ten seconds, before pressing stop. This speaks to an unspoken pact between DPs and editors, creating the opportunity to discover a gem, find a solution, or rewrite a scene with unanticipated footage. In the middle ground, after the slate and the call to "Action" and before "Cut," lives the anticipated realm of known material – the action and dialogue decreed by the script. Before "Action" and after "Cut" resides unknown territory. Many times it is unusable and ignored. But, on particular occasions, that unscripted material can save the day.

In many cases, the best endings are those where the writer has given the audience enough information that they could write the next moment, the next day, the rest of a lifetime. But sometimes an ending, whether of a scene or an entire film, is not satisfying. It wants something more.

Keep Rolling

A classic example of mining the footage that exists beyond the culmination of a take comes from the ending of *The Graduate*. Writer and director had struggled with a proper conclusion to Benjamin crashing Elaine's wedding and, in the final moments, stealing her away from the altar. As family and friends pursue them, Benjamin thrusts the church's cross into the handles of the door, effectively locking it from the outside. Then he and Elaine run for a city bus and board it. Here's how it played out in the original script:

```
EXT. STREET IN FRONT OF CHURCH - DAY

Ben and Elaine running along the sidewalk. Ben
holds her hand and is pulling her. She still
holds her flowers. They run to a bus that is
just closing its doors.

SHOT - BEN

He bangs on the closed door of the bus. The
door opens. Ben climbs the step into the bus
and pulls Elaine up after him. The doors close.
```

INT. BUS NO. 2 - DAY - SHOT OF BEN, ELAINE AND
DRIVER

Ben holds out a dollar bill.

> BEN
> How much?

> DRIVER
> Where do you want to go?

> BEN
> To the end.

The driver takes the bill and gives Ben some
change. Ben turns and pulls Elaine along to the
back of the bus. He pushes her into one of the
seats and sits beside her. Ben looks toward the
front of the bus.

BEN'S POV

He sees the driver and the passengers, all turn
around in their seats and looking back at them.

SHOT - BEN

> BEN
> Let's go. Let's get
> this bus moving!

SHOT - THE DRIVER

He turns and starts the bus.

SHOT - BEN AND ELAINE

They are breathing heavily.

> ELAINE
> Benjamin?

```
                    BEN
          What?

She takes his hand.

EXT. STREET IN FRONT OF CHURCH - DAY

Through the window in the back of the bus the
church can be seen receding in the distance.
There seem to be a number of men dressed in
black running around in the street in front
of it.
                              FADE OUT
```

Ben and Elaine make their way to the back of the bus with Elaine's wedding dress trailing along the floor as passengers watch. The couple have secured their devotion to each other and escaped from the confines of family expectations. But what now? It was inconclusive. How do you end a scene like this?

As it turned out, the camera kept rolling after "Cut," and there was born the breathtaking and truer ending – they took the leap, but they have no idea what awaited them. The couple sit and stare toward the camera as time passes. Beat, beat, beat. And, only after several long, uncomfortable moments, the movie ends. More was said in this silent moment than in all the scripted dialogue. Consequently, Ben's and Elaine's lines were left out of the final cut, and it became one of the most memorable moments in cinema.

For writers, this is instructive because it reminds us that it's worth taking the time to come up with a strong button to a scene. This is particularly true in sequences, where three scenes work together to fulfill an idea, forming a beginning–middle–end design. In cases like this it can be beneficial to leave the initial scene open-ended so it invites the viewer into the next scene and the one after that, finally concluding with a big payoff. At other times, however, its crucial to find a solid ending to a single scene. Neglecting to do so is like telling a joke without a punch line. A button can be large and dramatic, as in the photography scene in *Get Out* (2017) where a seemingly friendly introduction turns into a horrific reveal when the main character, Chris Washington (Daniel Kaluuya) surreptitiously snaps a photo of another Black man (Lakeith Stanfield) whom he encounters during a mainly white gathering at the home of his girlfriend's parents. Or it can be lighter and more subtle, such as the ending of *The Graduate*. Either way, the impact on the audience should be substantial.

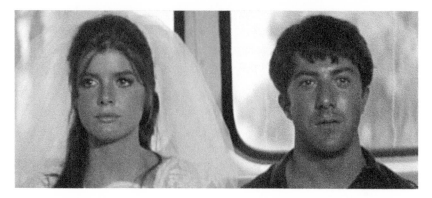

Figure 5.1 The Graduate – Ben and Elaine in the back of bus.
Credit: United Artists.

Figure 5.2 Get Out – The smartphone photography scene.
Credit: Universal Pictures.

Discovering What to Lose

The job of a scene is to inform us about the character and to advance the story. This is a good yardstick for what is included and what is superfluous in a film story. Some scenes, rather than advancing the story and character, actually run contrary to our understanding of both. These should not be in the film. A scene that contradicts the plot or the character's nature is even more dangerous than one that remains neutral.

In the case of another scene from *Horseplayer*, I realized after sitting with the dailies for a while that the sequence I was cutting couldn't work as scripted. It stole all empathy from our main character, Bud, when he kills another character whom we had come to like and who didn't deserve his vengeance. In the dailies, Bud, in a fit of rage, clubs his boss (Vic Tayback) to death with a ceramic figurine.

After discussion with the producers and director, we agreed that it wouldn't work unless a different approach was taken. What if Bud didn't kill his boss, but instead changed his mind and put down the figurine in defeat? And what if the boss, who had fired him and had been yelling at him, gets the last word? Now we have a character who arouses our sympathy rather than our dislike. Bud would be driven to the point of violence, but he can't go through with it.

To accomplish this was a matter of cutting out the subsequent scenes that showed Bud dragging his boss's body to his car and driving the corpse to the Los Angeles River. Since Bud had been fired, we wouldn't see the boss again, so it wasn't necessary to establish where Tayback's character went. But the crucial moment was found in one take where the DP hadn't heard the director call, "Cut." The actor, Dourif, broke character, turned away, and put down the figurine. That one moment changed the entire trajectory of the film.

Figure 5.3 Horseplayer – Bud threatens his boss with a plaster figurine.
Credit: Greycat Films.

A simpler but equally effective use of scavenged footage came from *Poison Ivy 3* (1997), a film about a young woman, Violet (Jaime Pressly), who comes back with a single strong purpose, to revenge the treatment

of her mother by the well-to-do Greer family, including Violet's former friend, Joy Greer (Megan Edwards). In an attempt to seduce Joy's father, Ivan (Michael Des Barres), Violet swims topless one morning in the backyard pool as Ivan is about to leave for work. He notices her and watches from his second-story bedroom window, intrigued. Eventually, his voyeurism is interrupted by the housekeeper, Mrs. B (Susan Tyrrell), who offers him coffee.

```
                    MRS. B
            More coffee, Mr. Greer?

Ivan turns to find her standing in the doorway
with the coffee pot in her hand. Taken by
surprise, he nervously responds.

                    IVAN
            N-n-no, I'm fine. Thanks.

He stands rigidly until she turns to leave.

                    MRS. B
            You might want to think about
            cuttin' down a little, Mr. Greer.

Mrs. B makes a face at Ivan's odd behavior as
she leaves.

Ivan rolls his eyes, hoping to get out of the
house without further notice.
```

In Karen Kelly's script, the scene ends there. During production, actor and director added an extra beat that supplied a good button to the scene. In the dailies, Ivan looks back out the window, pressing his lips together and sighing when he sees he's missed Violet. What we don't see is that she has left the pool, which would motivate his disappointment.

It is often helpful to mine the footage after "Cut" but it can also be beneficial to view the footage before "Action." In this case, the high angle (Ivan's POV) of the swimming pool, which would make an excellent conclusion to the scene, still contained the actress after "Cut." But there were multiple takes, and on one subsequent take the scene was slated before Pressly re-entered the set and found her mark. The pool was empty, but the water was still disturbed from her having swum in it during the previous take. This was the perfect shot to wrap up the scene and just long enough before the slate rose into view and blocked the sight of the pool. This became the end to the scene.

Figure 5.4 Poison Ivy – Ivan gazes out the window toward the pool.
Credit: New Line Cinema.

Figure 5.5 Poison Ivy – Ivan's POV of the empty pool.
Credit: New Line Cinema.

Instead of concluding on the interaction between Mrs. B and Ivan, the edit was able to refer back to the main motivation of the scene (the intended seduction of Ivan) and supply a complete ending: Ivan looks out the window, sees the pool is now empty, and grows disappointed, but not without first having his interest aroused. All this before Violet finally succeeds in seducing and killing him.

The script's point that he's "hoping to get out of the house without further notice" – an attitude that can't easily be portrayed or shown – is replaced by a clear reaction: disappointment. Additionally, the unnecessary and conflicting line – "You might want to think about cuttin' down a little, Mr. Greer" – was replaced by the actor's short and grumbled acknowledgment. After all, why would Mrs. B offer more coffee when she thinks Ivan should cut down on his caffeine intake?

Between writer, director, editor, and actors, the scene came together, and, in a rare instance, not one frame was changed from the rough cut to the final release print.

Movies Move

In a presentation during the Academy nominations, Andy Jurgensen, the editor of *Licorice Pizza* (2020), talked about his and the director's approach to various scenes. The film, influenced by Paul Thomas Anderson's experience growing up in the San Fernando Valley in the 1970s, follows the budding romance and adventures of Alana Kane (Alana Haim) and Gary Valentine (Cooper Hoffman).

In the Tail o' the Cock restaurant sequence with Tom Waits and Sean Penn, the filmmakers had more coverage and more action than was needed. "That [scene] was a lot longer and … [I] had to whittle it down to the essence of it, which is a crazy kind of drunken whirlwind." He and the director didn't want the scene to lag, so they found themselves constantly trimming. According to Jurgensen, "You had all these different perspectives. And you just didn't want to get bogged down. You wanted to keep it moving, keep it crazy and get outside for the whole motorcycle part." Yet, through all the wild escapades, the relationship between the main characters, Gary and Alana, remained their North Star, the guiding light to which everything ultimately related.

Figure 5.6 Licorice Pizza – The Tail o' the Cock restaurant scene.
Credit: Universal/MGM.

Jurgensen explains that the director didn't want people to get ahead of the movie. "He's like, the audience is smart enough. Maybe they'll be confused a little bit, but they'll catch up and it's fine." This specifically refers to the surprise introduction of certain characters, such as the appearance of the Jon Peters (Bradley Cooper) character. About mid-way through the film, Anderson introduces Jon Peters, who takes the main characters on a wild ride and then disappears from the movie, sort of as one would experience in an adventure film. In that sense, this is a nostalgic urban adventure.

In the script, it wasn't set up in the way scripts traditionally try to prefigure characters and their actions. This spontaneity, along with the period songs, helped perpetuate the film's madcap pace and rhythm.

In developing a character around the living legend of Jon Peters, the writer–director Paul Thomas Anderson consulted with Peters, who kindly encouraged him to portray him as a jerk, a much more fun and dramatic character than one who was friendly and non-threatening.

Writer–director Anderson's and his editor Jurgensen's goal is a useful guide for writers in general – come in late and get out early. Their aim was to keep the momentum going, "Keep it moving, keep it moving."

Note

1 Bartlett, Frederick. *Remembering: An Experiment in Experimental and Social Psychology.* Cambridge University Press, Cambridge. 1932. For a further analysis of Bartlett's theory, see Mlodinow, Leonard. *Subliminal.* Vintage Books, New York. 2013.

6

WHAT WRITERS KNOW

The chapter explores principles that all good writers know: how an understanding of story structure, character, mythology, dialogue, and subtext informs the writing process. Editors benefit from understanding these elements as well.

Writers hold the key to the kingdom. Without writers, there is no movie. From the initial inspiration, whether simple or high concept, the writer envisions characters, situations, and emotions, wrapping them in a well-constructed plot. The characters must be ones that an audience can identify with, because we all share similar desires, even if a character's expression of these desires is unfamiliar to the average person.

The character's actions may be reprehensible or divine, but they have an inner emotional logic. Their motives will conflict with those of other characters, and along the way obstacles will be thrown in their paths. In the end, there will be some sort of satisfying conclusion that relates back to the issues that were raised in the beginning. And somehow it needs to be brilliantly unique, briskly paced, emotionally fulfilling and endlessly engaging. A tall order.

Storytelling isn't just entertainment, though that may be its first order of business. Without engaging members of an audience and safely moving them from one place to another, there is little possibility of affecting their hearts and minds. They are passengers, and you, the writer, the trusted pilot.

Stories, particularly film stories, require structure. While it may at first appear formulaic structure, is the skeleton that everything else – character, theme, action, dialogue, plot, and other elements – hang on. The individual elements and the structure that contains those elements are inextricably intertwined. And all these exist to perform the impossible task of perfectly depicting the complexity of human experience.

Consider ideas. Ideas come from our experiences, memories, goals, fears, desires, regrets and so on. These seemingly separate elements make up one

DOI: 10.4324/9781003161578-7

whole – the thinker. Thinkers – we – do not exist without something to populate our thoughts. We are the structure created by our stories. In that way, we are not separate from our thoughts, though most of the time we tend to assume that to be the case.

We struggle to change our feelings and actions, unaware that the entity that attempts this change is the same one that creates the problems. That's the basis of film stories, whether it is obvious or not. Characters in films suffer based on their emotional decisions rather than on clarity through facts. Films work because they evoke those feelings. Films that preach and intellectualize generally fail. If characters acted reasonably and rationally, all movies would be short ones. Instead, before the end of the tale, some crisis has occurred that reveals the truth and makes it impossible for the characters to continue in their habitual ways.

The stories that we tell are full of the same elements that churn around in our heads. Stories are a way of trying to make sense of human experience.

Movies are visual and auditory. In that regard, screenplays create story by outlining a series of images, sounds, spoken words, even music, that are connected through action that follows a particular throughline. Most screenplays use the basic three-act structure that goes back to Aristotle as he described it in his *Poetics*. All this is within the dramatic framework that requires conflict in order to build drama. The first act is the set-up, the second act develops the conflict by introducing further obstacles, and the third act resolves the conflict.

Tasked with the awesome responsibility of caretaking the original writer's work, it is incumbent upon the editor to be thoroughly acquainted with what most writers know. This will shine a light on the path of each scene and act as a guide for the editor entering the sometimes dense thicket of the dailies.

When editors sit down to construct a scene, they tell themselves a story. The story may closely resemble the scene before them or it may deviate significantly in order to fulfill the aim of the script. Either way, the internalized tale acts as a guide to solve the intricacies and lapses that can exist in dailies.

Editing, as we've come to see, isn't just putting the pieces together so they make sense or achieve a compelling flow. Editing is rewriting and, as such, belongs in the realm of story, character, and structure that pervade the writer's craft.

Structure

The first element that becomes clear is the need for structure. Some of this has already been mentioned regarding the three-act structure that makes up our stories. In the first act, a desire will be introduced. Along with

that, the inevitable problem arises (or is prefigured). Before the end of the first act there will appear a turning point, a complication, or new piece of information that sends the story in a new direction. In *Casablanca*, it's the moment when Rick sees Ilsa, his former lover who, he believes, abandoned him in Paris. The end of the first act occurs when the main character first decides how they will deal with the issue raised in the inciting incident.

The second act is the longest trek and is broken up in the middle by a new and profound conflict. By the end of the second act, a new turn presents itself. In *Casablanca*, Ilsa is about to shoot her former lover in order to obtain the coveted letters of transit. Things grow darker. There are premonitions of death. But something happens to show us a glimmer of light at the edge of the glen. Everything will be better – until it's not. The world collapses in around us. Only in the last moments do we finally arrive at our destination, and all is saved or, if not saved, somehow resolved.

These are some of the basic steps along the way. Volumes have been written and lectured about this, but it basically boils down to these elements. This is the first thing that editors must keep in mind – they are working in a realm where maps have already been drawn. But just because there is a map doesn't mean the journey will be easy or straightforward.

For some writers, carefully following all the rules and principles of craft helps guide them as they commit ideas to the page. They may work from detailed outlines and fill in the blanks as they go. Others have integrated these concepts to the point that they intuit the next steps as they move through the story without looking back. Still others find that concentrating too heavily on the rules at the beginning is distracting and stymies the creative process. For them, the rewriting process is where they will summon the most help in order to determine what is missing, what is working, and what isn't. Learning these principles gives you an idea how to fix problems when you encounter them.

Editing has a set of basic rules as well. During the editing process, all the principles of continuity editing tell us what works and what doesn't, but this also allows us to break the rules knowingly, when we are inclined. To break continuity or create a jump cut trespasses on several basic principles, but, when used well, these maneuvers can enhance a film. In the 1950s, filmmakers of the French New Wave first showed this to be the case. The jump cut was born, creating ellipses within a scene that defied the established conventions of time and space. In Jean-Luc Godard's classic *À Bout de Souffle*, aka *Breathless* (1960), characters pop in and out of frame, appear on one side of the room and, in an instant, on another.

Before the 1950s, a jump cut was considered an egregious error. After *Breathless*, editors continued to show how effectively jump cuts can work, and the technique eventually became a staple of filmmaking. Just as a writer might use a sentence fragment, an editor will use a jump cut. But both must be applied purposefully. Not by mistake.

We see the jump cut alive and well today in such films as *Dune* (2021), where the editor, Joe Walker, capitalized on the editor's ability to jump time when showing process. To carry out every stage of a process can be tedious, but, by selecting only the most telling moments, the editor moves the film along and establishes a continuity of rhythm and emotion, even when the shots are discontinuous.

Look back at the example of *Jojo Rabbit* in Chapter 1, where 10-year-old Jojo puts on his uniform. The script outlines a series of jump cuts as Jojo buttons his shirt, pins his badge, tightens his belt, and so on. These are all actions that could be performed in a linear manner, but here quick images jump the story ahead in an engaging way. Notice that, in the script, the jump cuts appear as incomplete sentences, such as "Hair combed."

Understanding dramatic structure can take time. For most people, it doesn't come easily. Well-written stories make it seem simple, but, on the contrary, it is quite complex. Yet, once understood, it becomes second nature.

Many different screenwriting gurus exist to offer pathways and instructions for the writer. Some of the best of these are Syd Field (*Foundations of Screenwriting*), who designed a paradigm of the screenplay, and Blake Snyder (*Save the Cat*), who mapped out the beat sheet that writers can follow. But there are many others who have spoken directly or indirectly about the structure of story. One of the best and earliest to lay down the principles for modern dramatic structure was George Pierce Baker, a professor of English at both Harvard and Yale, in his classic book *Dramatic Technique*. Joseph Campbell, while not a screenwriter, has shed light on the ancient and mythological origins of story. In doing so, Campbell influenced many filmmakers, the most prominent being George Lucas in his *Star Wars* series. For a fascinating evocation of Campbell's concepts, check out the interview series *The Power of Myth* (1988) with Paul Moyer and Joseph Campbell at Lucas's Skywalker Ranch.

Campbell, a popularist, was influenced by a truly original thinker, the Swiss psychologist Carl Jung, who revealed the concept of archetypal stories that transcend current time and events. In the writings of Jung, it becomes clear that stories resonate with us partially because they fulfill a primordial need that connects us to all human beings throughout time.

This is the greatness of storytelling. It creates empathy for people and places we may never know or see because we discover that their problems are our problems, just framed in different traditions, different cultures, different locales. If anyone ever says to you, "Art is nice, but it doesn't save lives," imagine going through the Covid-19 pandemic without music, without books, without video games, without films.

So, what are these stories that the brain and heart respond to, that take us away to another realm that ultimately brings us back to ourselves?

People have tried to catalog all the essential stories and, though the number may vary some, it appears that the basic stories are limited in number. How we bring them to the screen varies in tone, execution, and character.

Oscar-winning screenwriter Ben Hecht once asked a producer, who was interested in engaging him to write a screenplay, "What kind of story is it?"

The producer said: "It's a love story."
"Every story is a love story," Hecht replied.[1]

If we consider the way stories work, there's some truth in Hecht's slightly facetious remark. After all, your characters will fall for each other, they will argue, they will break up, they will reconcile. They will follow a three-act structure.

At first, there will be the courtship, the desire, the intention. Hidden in the desire is not only the want for the love object (whether in human form or in the guise of power, wealth, or fame), but also the deeper need, the one that may ultimately destroy the lovers by bringing them into conflict. If you think about it, most relationships start off easily at the beginning, but eventually life gets complicated as obstacles get in the way. Everyone, we discover, has a motive, and one motive can conflict with another, whether it is to have security, companionship, defuse a bomb, or find happiness.

There are three main obstacles that characters encounter on their way toward a goal. Sometimes those conflicts arise from their connection to others ("Hell is other people,"[2] Jean-Paul Sartre once espoused). Some of those great stories are *The Scarlet Empress* (1934), *Casablanca* (1942), *Breathless* (1960), *Dr. Zhivago* (1965), *Who's Afraid of Virginia Woolf?* (1966), *The Graduate* (1967), *E.T. The Extra-Terrestrial* (1982), *Out of Africa* (1985), *Raise the Red Lantern* (1991), *Farewell My Concubine* (1993), *City of God* (2002), *Slumdog Millionaire* (2008), *Get Out* (2017), and *Black Panther* (2018). Many of these films also won awards for editing and writing. What is your list?

At other times, stories may arise from an internal conflict, something within the person that drives them to power or destruction or glory.

Citizen Kane (1941), *On the Waterfront* (1954), *Lawrence of Arabia* (1962), *8½* (1963), *Network* (1976), *Tootsie* (1982), and *Leaving Las Vegas* (1995) are some classic examples.

And sometimes obstacles come from the outside, from our infatuation with nature that, as Rainer Maria Rilke observed, "so serenely disdains to destroy us."[3] Check out *Key Largo* (1948), *The Birds* (1963), *2001: A Space Odyssey* (1968), *The Poseidon Adventure* (1972), *Jurassic Park* (1993), *Twister* (1996), *Titanic* (1997), *The Perfect Storm* (2000), *Contagion* (2011), or *Don't Look Up* (2021). Additionally, there's the supernatural, such as *Dracula* (1931), *Topper* (1937), *The Wolf Man* (1941), *Cat People* (1942 and 1982), *Heaven Can Wait* (1943 and 1978), *The Ghost and Mrs. Muir* (1947), *Carrie* (1976), *The Shining* (1980), *Ghostbusters* (1984), *Dune* (1984 and 2021), *Prancer* (1989), *Ghost* (1990), and *The Sixth Sense* (1999).

If we think of all stories as love stories, it gives us permission to fall in love with our characters, even the nasty ones. Because even the nasty ones have qualities we recognize in ourselves when we're not at our best, when we're greedy, vengeful, jealous, or deceitful. These stories are about the eternal human need to make connections, to be guided by our hearts, to solve the impossible problem, and along the way to discover the failings of those connections and to rise above. These are the great stories that weave through our consciousness.

Genre

Another aspect that writers attend to is genre. This is an overlay of our love story structure. There are love stories where one of the lovers will be betrayed and killed (thrillers). There are love stories where people laugh and make love, misunderstand each other, and eventually marry (romantic comedies). There are love stories where we are awestruck by the majesty of something larger than ourselves (science fiction and Westerns). Each has its own trajectory, its own archetypal structure. In this way, they raise specific expectations in an audience. Not fulfilling those can undermine the viewer's experience. This is not to say that these expectations need to be or should be met in a typical or predictable way – a trope. As a matter of fact, it's better that the formula remains hidden in some unique treatment of the genre.

Sense and Setting

In story, setting plays an essential role, whether it is the wizarding school in *Harry Potter and the Sorcerer's Stone* (2001) and its subsequent sequels, an Eastern European train station in *Closely Watched Trains* (1966), or a charmed Colombian town in *Encanto* (2021).

Figure 6.1 Harry Potter – Establishing shot of Hogwarts.
Credit: Warner Brothers.

Figure 6.2 Closely Watched Trains – The train station.
Credit: Criterion Collection.

Figure 6.3 Encanto – The family home.
Credit: Walt Disney Pictures.

The physical appearance of people and places will be determined by the production designer, art department, and director. But by incorporating setting into a script, the story is enhanced by the environment's influence. Just as with scenic descriptions in the script, however, adding too many scenic shots can weigh the film down. Generally, it is better to evoke the setting through the actions of the characters within the environment.

In that way, excessive establishing shots at the beginning of a scene are usually avoided and will confine themselves to the **rule of three**. In other words, one establishing shot may not be enough to evoke the setting, while four or five will be too many and slow the story. Generally, three is just right.

The Rule of Three: A symmetrical writing principle stating that items that occur in patterns of three are more potent than in other configurations, such as once, twice, or four times. The triumvirates of beginning, middle, and end; cool, calm, and collected; or friends, Romans, countrymen represent classic occurrences of the principle. *Omne trium perfectum* = everything that comes in threes is perfect.

The philosopher Ortega y Gasset made a fascinating observation when he spoke about how the ancient hunter felt and experienced the natural world by his participation in it.[4] One is not separate from the other. In

the same way, films do well to fold descriptive shots into the overall flow of the action. Writers can find guidance in how to evoke a setting and sensation by viewing a well-edited film.

Check out the world building in *Dune* and the use of sensual details and insert shots to convey a feeling for the world. Setting and certain visual clues can create what editor Joe Walker, ACE refers to as "brain stemy images," that communicate faster than words "by appealing to some part of the brain that's old and not necessarily verbal, [but] sensory."[5]

One example is when Lady Jessica Atreides is getting ready to depart her home planet, transitioning from a world she knows to a new and mysterious one. The idea of leaving takes on emotional weight in the sequence where Lady Jessica's son Paul Atreides (Timothée Chalamet) prepares to leave, and we see the dangerous environment of Arrakis in contrast to his familial home. His thoughts of leaving become mirrored in images that lack continuity of action, location, and time. It becomes a sort of tonal montage, in the Eisensteinian sense, where the collected images impart a feeling, such as the shot of Duke Leto's hand comforting his concubine, Lady Jessica. Says Walker:

> The shot of Lady Jessica waiting as the bull is being packed into a packing case and she's about to leave her home for all of her life and step onto a planet where death and disaster awaits and there's a moment just focused on the back of her neck and you feel her anxiety and then Leto's hand comes in and reassures her and it's the hand on the neck which we all know what that feels like … but also what it says about the trust between those people … It's finding a way in the edit to give those images the best payload.

Figure 6.4 Dune – The comforting touch.
Credit: Warner Brothers Pictures.

In the script, this moment appears as only a few words.

```
INT. GREAT HALL - DAY

Servants lower a mounted bull's head into
a case. Leto and Jessica look on. Around
them, the castle stands cavernous and
empty.

Paul close behind, observes his mother.

Servants come to say goodbye, weeping and
embracing them. The Atreides are beloved:
their household is a family. Jessica tears
up. Leto comforts her.

Paul joins them.

The bull head's case is being closed.
```

These details, which were alluded to in the script by "Leto comforts her," are fully realized by the director and editor, giving the audience a deeper, more primordial sense of the characters and their feelings. In a script, when trying to evoke a sensual experience, consider adding a line or two to allow the reader to fully envision an action, such as to comfort, arouse, or excite.

Notes

1 Frank P. Rosenberg. Personal communication with the author.
2 Sartre, Jean-Paul. *No Exit*. Vintage International, New York. 1973.
3 Rilke, Rainer Maria. *Duino Elegies*. Translated by C.F. MacIntyre. University of California Press, Berkeley. 1965.
4 Gasset, José Ortega y. *Meditations on Hunting*. Charles Scribner's, New York. 1972.
5 Huffish, Steve. "The Art of the Cut, Ep. 135. 'Dune' Editor Joe Walker, ACE." 27 October 2021. Anchor.fm/frameio-insider

7

WHAT EDITORS KNOW

This chapter explores the principles that all good editors know. How an understanding of editing rhythms, genre expectations, intercutting, subtext, and structure can inform the writing process.

Editors deal with the same issues as writers, with one prominent exception. They don't start from scratch. They already have material waiting for them in the form of a script and, eventually, dailies. As we will see, the approach to that material comes with its own challenges – the need to fashion elegance and perfection out of an abundance of choices. In many cases, the material has experienced the best possible birth, been well cared for, nursed by a parade of people from cinematographers to actors to costume designers. Their efforts form a large collection of possible decisions, mistakes, wish lists, and redundancies. Out of all this, editors must use their well-developed sense of story, structure, pacing, and character to fulfill the script and craft the director's vision. In the best cases, they go beyond the director's expectations.

Joe Walker points out that,

> You're trying always as an editor [to stay] in parallel or ahead of the audience, slightly ahead, not too far ahead and never behind. If you're behind you're dead. If they already know how the scene is going to end, if they already know how the story is going to end, if they already know how it's going to resolve, then you're dead if you allow (the audience) the time to … figure it out.

Power of the Shot

Screenwriting and editing techniques, such as those devised by the Russian film school of Eisenstein, Kuleshov, and Vertov, evolved simultaneously at the dawn of the 20th century when the initial novelty of the movie camera and its ability to capture reality in a single moving image captivated

 DOI: 10.4324/9781003161578-8

audiences. These simple, singular incidents evolved to the coverage of an event from various camera angles. These different angles needed to be spliced together to tell the story. The resulting juxtaposition of images created by placing one shot next to another produced a stronger impact, greater meaning, and more compelling timing than resided in a single shot, a oner. Chopping up the images and fitting them together in creative ways allowed for the manipulation of time, space, structure and rhythm, the editor's greatest impact on cinema.

Influenced by the editing process, screenwriting grew to map out the proposed story through an outline of shots and scenes, sequentially imagined. All this before the invention of synchronous sound. The stream of images was basically all the filmmaker possessed in order to tell the story. The first screenwriting book, *The Technique of the Photoplay* by Epes Winthrop Sargent, appeared in 1911 and mirrored this new approach to writing. It was not writing in the strict sense but a story told by successive images.

Editing multiple angles allows for the selection of point-of-view. Well-written screenplays establish a point-of-view that the editor will come to reinforce through shot selection and by favoring one character over another, often through more frequent appearances and closer shots. Editing gives us glimpses into how each character sees or perceives the event before them.

Sculpting the Story

Editing is rewriting, intended not to alter the narrative – though that happens – but to select only the most salient features, shots that will tell the story, while eliminating those that don't – an economy of elements. The editor, like a sculptor working with marble, chips away everything that is not the story, removing all inessential elements.

Here, the editor is like a writer but a writer who has the luxury of a big, sloppy first draft. Some of the great writers, such as Julius Epstein (*Casablanca*), have taken the approach of initially getting the material down on paper, no matter how messy or awkward. Epstein used to throw everything into a first draft, so the initial manuscript amounted to almost 400 pages of screenplay, an unfilmable length. After that first pass, he would put it aside for a while knowing that, when he returned to the work with fresh eyes, the best material would clearly present itself. Everything else he would cut out. In this rewrite, he discovered the essence of his screenplay.

In a sense, editors are like Julius Epstein after he has written his initial draft. With volumes of footage and a more objective eye than writer or director at this stage, editors are free to discover the best performances, the most informative camera moves, the tightest and most engaging construction. Editing is indeed rewriting.

 For Editors: Additional to the aesthetics require-ments that make an expert editor, there's a techni-cal aspect that overlays the entire process, and each year it becomes more complex. Editors, unlike writers, producers, and even some directors, need to be highly technologically adept. Daily, they work with high-capacity hard drives, cloud storage systems, powerful computers, and complex software such as Avid Media Composer and Premiere Pro. But more than that, they, like writers, have to have a deep com-mand of story. This aspect can be overlooked by those who imagine editors to be like carpenters following a blueprint. To truly become an editor, one needs to understand the writing and storytelling pro-cess. That is where the true gift of the profession resides.

Structure is deeply imbedded in the screenwriting process and so too in editing. Dramatic structure has evolved to some degree over the centuries, but Aristotle's three-act structure and conventions of time and space still hold sway. Structure relates not only to the three basic acts that make up a dramatic work (as well as the plot points and twists along the way) but also, as editors often find, to each scene and moment of action, which are mutable. Structure isn't only mathematics, it's music too. Editors will tell you on occasion that they have taken the beginning and placed it at the end or vice versa. They frequently move the puzzle pieces around for best effect. Why is this even necessary? Often, scenes that play well in a script and appear to be essential discover a new home farther down the road or else disappear entirely. In some cases, a studio executive, producer, or director may identify a particular scene as boring and encumbering the film's flow. They feel it should be cut out. But it contains essential information. Something else is wrong. As editor Bruce Green, ACE, (*The Princess Diaries*, *Cool Runnings*) points out, "When you go in and exam-ine things, what you realize is that three scenes back there's a scene that there's no need to have. And if you take out that scene, then everything that comes after it plays faster."[1]

This reflexive effect applies to writing too. Before removing or rede-signing a scene that contains essential elements, examine the surrounding sequences and determine if an earlier scene has influenced the perception of the later one. Stories have a holistic quality. Changing one aspect inevi-tably affects other parts of the whole.

In dramatic structure, something needs to capture the audience's atten-tion and concern, but determining the right position can be challenging. What may have seemed like an engaging way to begin a film may prove otherwise when the pieces are finally edited together. An opening **hook** is

essential and needs to be well suited, just as the ending needs to fall in the proper place and have all the necessary beats, no more and no fewer.

 The Hook: As the word implies, the hook grabs the reader and holds them with an unexpected question, problem, event, or statement.

Like the hook, the **inciting incident** captures the audience's attention early on and sets things in motion. It establishes the initial conflict, sending the main character on a journey that will engage them throughout the course of the story. The trick is to find the right event.

Establishing Tone

Sometimes, scenes that seem engaging aren't. Pamela Martin, ACE, the editor of *King Richard* (2021), described how she and director Reinaldo Marcus Green "struggled with the opening of the film [as scripted] because there wasn't a very strong hook and [the audience wasn't] fully invested with Richard (Will Smith) quickly enough."

In the script, the opening scene originally showed Richard collecting used tennis balls from various tennis clubs so he could have enough when he practices with his two daughters, Serena and Vanessa. "Then he goes home, picks up his girls, goes to the courts, goes to work and then starts pitching all the coaches" whom he wants to train his daughters. One by one the coaches reject his requests.

```
EXT. PALOS VERDES COUNTRY CLUB - VARIOUS
SHOTS - MORNING

A majestic, rolling golf course. Pristine tennis
courts. Rich WHITE PEOPLE living the life.

INT. PALOS VERDES COUNTRY CLUB - MORNING

Inside, UNIFORMED STAFF vacuum opulent locker
rooms and clean the framed photographs that
line the club walls:
ANCIENT TENNIS GREATS. TILDEN. KRAMER. AUSTEN.
SHRIVER. All legends. All white. All viewed by:
```

RICHARD WILLIAMS (47). A tall, powerfully-built black man with broken teeth, a graying beard, and a lifetime of rejection and resentment.

Richard stands in the pro shop in his TENNIS ATTIRE, when a TENNIS PRO arrives with a SHOPPING BAG.

> TENNIS PRO
> Grounds crew threw out most of
> 'em. Got a few here but they look
> pretty dead.

> RICHARD
> They not dead to us.

Richard looks in the bag. It's filled with RATTY OLD TENNIS BALLS. Richard takes it thankfully and without shame, heading out with his bounty as we hear -

> RICHARD (V.O.)
> Where I grew up, in Louisiana,
> Seedy Grove. Tennis was not a
> game peoples played. We was too
> busy running from the Klan. But
> here it is …

EXT. PALOS VERDES COUNTRY CLUB - VARIOUS SHOTS - MORNING

Richard's garbled Louisiana drawl continues as he strolls the manicured grounds, collecting stray balls as he goes. He plucks them from trash as WHITE CLUB MEMBERS play.

> RICHARD (V.O.)
> … when I'm interested in a thing,
> I learn it. How it works. How the
> best people in the world do it.
> That's what I did with tennis and
> the girls.

In the editing room, it became necessary to re-envision the script, moving scenes around and restructuring the story. It was the biggest deviation from the screenplay, but one that would eventually draw the audience

into the story of tennis champions Serena and Vanessa Williams and their determined and ambitious father Richard, for whom the film is titled.

Since the collecting tennis balls scenes didn't hold much dramatic promise, eventually Green and Martin

> decided to try this pitching the coach stuff up front and combine it with the ball collecting which we used just very little of. … That was key. Once we did that and opened the film in Richard's voice and saw the level of rejection he was facing from the very beginning, it really brought about emotion for this man. And you kinda rooted for him immediately as an underdog. And not only that, then he goes home and picks up his girls and he goes and works out on the court with them all day and then he comes home and he barely eats. He goes to his job at night, you can see how exhausted he is, and then he picks up the magazines and keeps working. Like the guy just doesn't quit and gets the last rejection from the Vic Braden character which really spells it out that he really has no business being in that business, not having the training that everybody else has. … Once we got that we were, "Oh my god, the first act is working."

As discussed elsewhere, point-of-view is an essential aspect of storytelling and here the use of Richard's voice combined with the sympathy garnered by the early scenes of rejection clarified the story and made Richard into the kind of protagonist that an audience wanted to follow and spend time with.

For writers, it's important to be aware of what the first scene is telling us. What tone does it set? Does it contain the main character? What does it allow us to learn immediately about the main character? And is it engaging enough to compel us to keep watching?

Figure 7.1 King Richard – Richard pursues coaches to tutor his daughters.

Credit: Warner Brothers.

Figure 7.2 King Richard – Richard collects tennis balls.

Credit: Warner Brothers.

While *King Richard* ran the risk of starting with events that were too mild and unengaging, *The Power of the Dog* (2021) had the opposite issue. Its beginning, as scripted, overpowered the more leisurely, character-driven scenes that were to follow directly after. Again, tone, pacing, and information influenced the film's structure during the editing process.

The film takes place on a Montana ranch (actually filmed in Dunedin, New Zealand) in 1925. As it follows the lives of the head rancher Phil (Benedict Cumberbatch) and his family, the story twists and turns, misdirecting us at times in terms of the characters' true natures and a sense of with whom the true power lies. In the original screenplay, written by Jane Campion and based on the novel by Thomas Savage, the story began with the castration of a calf on the ranch.

```
EXT - BURBANK RANCH/STOCKYARDS/PADDOCKS - DAY 1

A Montana ranch scape with a curious hill
feature, a sculptural outcrop that rises
up into a plateau. A man is looking at it.
PHIL BURBANK (40-50) tall, lean with a wry
expression that softens into something
speculative as he stares at the landform,
seeing something that causes him to smile,
some kind of private amusement. He walks on
until he's standing beside a GROUP OF COWHANDS.
Behind them a herd of Poly Angus steers mashed
six deep against a pole fence. Phil wears a
```

uniform of close fitting blue overalls and
worn wool chaps bare in patches. On his head
a hat so battered it's hard to know if it's a
cowboy or a sun hat. He's quiet, his sharp see-
all eyes watch. A big calf missed at spring is
pushed out of the pack, Phil points to it.

> PHIL
> That's him.

JUAN, MOUNTED COWBOY behind Phil gives fast
chase, a lariat hurled high in his right hand
snaps hard on the calf's hindquarters and
drops catching the animal's back foot. Phil
walks towards the struggling beast, a big
one with kick. THEO a BLACK COWHAND gallops
forward dismounting at speed, dust billowing
and helps throw the animal - a crushing thud.
TWO MORE COWHANDS run forward, together they
tie off the front and hind legs stretching
the calf out between the two horses' saddle
horns. Phil still walking with an easy grace,
unsheathes his knife and straddles the bull
calf facing his tail. The Cowboys holding the
calf look serious, their eyes on the dirt.
Phil takes hold of the scrotum and slices off
the cup tossing it aside. The calf struggles,
next Phil forces down first one and then the
other testicle, slits the rainbow membrane that
encloses them and tears the testicles out, he
unstraddles the calf and takes the dangling
testicles to a small branding fire, tosses them
over the coals where they explode in the heat
like huge popcorn.

> PHIL (CONT'D)
> You boys fooling with girls would do
> well to eat them.

Phil looks over at the Cowhands amused - no
takers. He flicks them out onto the dirt, a dog
carries one off to the end of the yard, the
veins and nerves trailing.

```
                    STAN
           One more lost boy, Boss.
```

```
The chase is on again. Phil once more straddles
the bull calf cupping his testicles in his
blood-stained, work toughened hands.
```

A startling and graphic scene. In practice, the scene as shot was so intense that its placement had to be reconsidered during the editing process. Tone is an aspect that writers, as well as editors, consider when constructing a film's opening.

Figure 7.3 Power of the Dog – Riding the range.
Credit: Netflix.

A rule of thumb that some writers use is "start with an emergency." An emergency can be anything from a fiery familial conflict to an actual life-threatening emergency. Some filmmakers, such as Brian DePalma (*Carrie, Dressed to Kill*), start their films with such harrowing events that the audience is on pins and needles throughout the rest of the film, wary that at any moment they'll be confronted with another such traumatic event.

More recently, the television show *Ozark* (2017) used this approach in the initial violent encounter between Marty Byrde (Jason Bateman) and members of a murderous drug cartel during a money laundering operation gone wrong. In order to placate the cartel and save himself and his family, Marty agrees to set up an even bigger laundering operation in the Ozarks.

During the inciting incident, the audience is immediately engaged by the conflict before them but also by the immediacy of the action. Rather than slowly ramping up to a critical event by mapping out the motivations and responses that led up to this moment, starting with a dramatic

encounter can pull us directly into the middle of the storm. In some cases, the *whys and wherefores* aren't immediately apparent, but the audience's attention is immediately piqued. They're excited to hang in there to learn the full nature of the incident. Along the way they have gained a sense of the film's overall tone.

In the case of *The Power of the Dog*, opening the film with a close-up castration established a precedent and tone that were not consistent with what followed. What followed was a rather restrained revealing of the difficult main characters. The larger challenge was to build enough suspense in the cutting that the audience felt eager to know more.

Later in the script, about midway through, there appeared another castration scene, but this scene was shot from afar. It happened more in the background, upon the return of the young foil, Peter, from school. Since this was a jump in time and a good place for a strong transition after the story's conflict had already been established, it became the ideal place to insert the more graphic and disturbing castration scene that was originally intended for the opening.

As the film's editor Peter Sciberras, explains it,

> We had this great castration scene that didn't feel right for the front. It was tonally too big of a bang to start on ... It also just started with a real spike of energy and then it kind of just threw off everything that came after it ... It felt like it was going in a certain direction and then it wasn't going there in the first ten minutes.[2]

Ultimately, the boarding house meal sequence became responsible for establishing Phil and his taciturn attitude. In this sequence, Phil rejects the meal that Mrs. Lewis has laid out for him, makes a chess move and a counter move on a board he has set up, and then saunters upstairs to the bedroom that he shares with his brother George, whom he immediately insults.

> Phil walks towards the bathroom door and
> continues playing (his banjo).
>
> PHIL
> Figured it out Fatso, what year we
> took over the Old Gent?
>
> GEORGE
> Why?
>
> PHIL
> Hell, think about.

```
    Inside the bathroom George sits placidly in his
    bath making small splashes. His skin is milky
    white except where his shirt was open and there
    his neck and his hands are red brown.

                    GEORGE
          You ever try the house bath Phil?

                    PHIL
          No I don't wanna smell like a piece
          of soap, like a flower. I like to
          smell like a man. What's happened
          to you brother? Don't forget the
          wilds or you'll end up a house cat,
          too fat to catch a mouse … Or are
          you a mouse?
```

There was a lot more of Phil and his brother George, along with Rose and Peter in the script, but that was taken out. Editor and writer–director Campion removed a lot of extra dialogue from the script. "Just about every dialogue scene had quite a bit of dialogue cut out … [to] boil it down to the absolute essential."

Removing other scenes made it possible to focus the story earlier, relying on the one big set piece in the red mill "to supply everything we needed to know." As discussed elsewhere, leaving out information can have the effect of drawing the audience into the story, sparking questions in their minds. In this case, the moment in the boarding house when Phil suddenly refers to his brother George as "Fatso" ignites the audience's attention and curiosity to know what motivated that offhand and cruel remark.

From the Fatso moment onward, tensions build, primarily through the use of images, dialogue, and pacing. Says Sciberras, "[Cumberbatch] just gave you kinda nothing but everything at the same time." He was disturbingly disarming for the other characters to be around, and suspense grew out of the anticipation of what he would say or do next. "It was a really fun dynamic to cut with Phil especially … You just sit on [a shot] for a longer time than you normally can. Just a shot that's not doing very much." Much of the feeling was found in his looks. As writers discover, sometimes a look can say more than even the most clever dialogue line.

Notes

1 Bruce Green, ACE. Interview with the author.
2 "Power of the Dog Editors Round Table: Peter Sciberras." Moderator Dylan Tichenor. Netflix Queue/Motion Picture Editors Guild. March 1, 2022.

8

TRICKS OF THE EDITOR'S TRADE

The chapter explores editors as magicians repurposing shots and establishing setting. It looks at the intercut as a valuable tool for creating rhythm and increasing tension and how it also serves writers, contributing to engaging scripts. Point-of-view is considered, as tracked and adjusted in the editing room, as well as ways of determining and reinforcing a character's point-of-view.

The Magician

Editors are like magicians. They make objects and people appear and disappear. They control time. And they employ sleight of hand to guide the audience's attention through the shifting landscapes of film stories. Editors manipulate perception over a seemingly endless and seamless progression of cuts, giving the impression that the story unfolding before them moves in an unbroken succession. The tricks that editors carry up their sleeves include the use of the intercut, point-of-view, rhythm, pacing, and the shifting of shots, as in the magician's classic cup and ball trick.

Repurposing Shots

Some stories are directly based on historic events, such as *Schindler's List* (1993), *Saving Private Ryan* (1998), or *The Trial of the Chicago 7* (2020). In all stories, the writer conceives of a space for the action to take place and characters to populate that space. Dialogue that is untethered to a locale eventually must find a place to land.

In structuring scenes, writers sometime dive in with characters and their conversations before they know where they'll place them. This allows for the free flow of ideas, devising conflict and personality without yet housing them in an environment. But environments have their

DOI: 10.4324/9781003161578-9

own personalities and stories to tell. Without carefully conceiving of how characters will interact with each other within a place, the writer runs the risk of holding back important information from the audience. Ultimately, the editor, who has the advantage of the dailies captured within a geographic context, will strive to achieve clarity through these physical elements.

Chase scenes, for example, rely heavily on geographic foundations, and, in cutting those scenes, the editor strives to build clarity through guidepost shots, wide shots, and point-of-view shots.

A simple example of the influence of environment appears in the courtroom scenes in *The Trial of the Chicago 7* (2020). As the writer–director Aaron Sorkin described it in a Netflix special, a shot of the empty jury box, which was in the writer's mind when conceiving the scene, was not stated on paper, and it took the editor to borrow the shot from a later scene to bring clarity to the earlier one. Sorkin concludes, "really good editors [are] co-authors of the movie.[1]

In the case of the *Chicago 7*, Sorkin noted that a shot of the empty jury box was designed to precede the sentencing of the defendants, as indicated in the script. During the editing process, it became clear that, in an earlier scene, when Ramsey Clark (Michael Keaton) was testifying without the jury present, they needed a similar shot of the empty jury box. Consequently, the editor, Alan Baumgarten, ACE, stole the shot and placed it within the earlier scene.

Says Sorkin,

> it didn't occur to me writing it or shooting it … that we needed to see the empty jury box so that we understood … it was important that Ramsey Clark was giving his testimony without the presence of the jury and it was important that the judge wasn't going to allow the jury to hear it. … I never put it in the stage direction, never talked about it.[2]

This speaks to the importance of living the scene and conceptualizing how it will be edited. Sorkin has spoken elsewhere[3] about his tendency to perform scenes as he writes them, acting out the lines, pacing out the blocking, so he is already delving deeply into the scene.

In designing your screenplay, think in terms of what each shot says and how it forwards the main characters' wants. As outlined elsewhere, in *The Healthy Edit*, one can design a shot list based on how the characters move through a scene while trying to achieve a particular goal. It is not enough to select shots purely for their attractiveness, uniqueness, or breadth; they should be selected for what each one means in and of itself, how it forwards the story and emotions. Its utility. In that case, it helps to think in terms of the neutral shot, the shot that does not carry wider meaning. A hand is just a hand, an eye is just an eye, and a knife is just a

knife. How these shots are sorted and arranged is what builds meaning and tension.

Despite the attention given to all-encompassing shots, those shots that tell many sides of the story in one move generally pale compared with the simple, unencumbered, neutral shot. The uninflected image often pulls the most weight because it works in conjunction with other shots. If the writer puts dialogue aside for the moment and mentally builds a string of images that each have a singular meaning, without asking any shot to carry the full story, he or she will liberate greater meaning through the juxtaposition of images. The third rung of the **editing triangle.**[4] This awareness came to the Russian filmmakers Kuleshov and Eisenstein in the beginnings of cinema. This still serves editors to this day. Writers can benefit from a similar approach. In conceiving a scene as if building a shot list, the writer can walk step by step through the action and discover the missing elements that might cause confusion in an audience. Upon discovering these missing pieces, the writer can include them in the script.

Parts of the opening chase sequence in the screenplay of *Baby Driver* (2017) read like a shot list, so one can easily imagine how the scene will play out in the film. Notice also the use of intercutting:

> WOOP WOOP. One BLACK & WHITE cruiser screams the opposite way. It zooms past, then makes a 180 behind them.
>
> Baby sees the Black & White BEHIND. A light turns red AHEAD.
>
> He floors it through the stop light. Other drivers break hard round him. Cars crash, rear end in time with kick drum hits.
>
> The Black & White flies through the intersection …

The Intercut

The intercut is a powerful tool of film editors that can greatly benefit writers. It involves the juxtaposition of images in a dialectical manner. At a basic level, the intercut varies perspective and fractures time. It introduces contrast by varying shots or scenes. Dialogue editing can be viewed as a series of intercuts between one character and another engaged in conversation. In action scenes, intercutting adds variety and accelerates the pace. By intercutting shots of shorter and shorter duration, the editor can also create rising momentum, increase tension, and build toward a climax.

Entire scenes can be intercut with other scenes, as each promotes a different idea, concept, or mood. At each intercut, one scene reinforces or

opposes the information communicated by the other. The power of this tool is sometimes underestimated, particularly by those who hold allegiance to single takes to tell the story.

As Eisenstein observed, when looking at Chinese and Japanese pictographs, the pairing of one image with another creates greater, stronger, and even transcendent meaning. A subset of the intercut is **parallel editing**, which first occurred in the classic Western *The Great Train Robbery* (1903). From our perspective today, it is hard to imagine a time when parallel editing didn't exist.

Parallel Editing: The process of maintaining two different storylines running concurrently. This is achieved by cutting back and forth between the action in one location and the action in a different location, presumably happening at the same time.

Prior to *The Great Train Robbery*, filmic stories proceeded in a completely linear and straightforward direction. With the introduction of an intercut between the escaping robbers and the train station where the hapless station master had been left tied up, and then back to the robbers on horseback, the director, Edwin S. Porter, showed audiences action that was occurring simultaneously in different locations.

As effective and enduring as the intercut remains, writers sometimes neglect its importance. Scripted scenes tend to play out in full before moving onto the next scene.

A striking occurrence of this happened in the romantic comedy *Totally Blonde* (2001), starring Michael Bublé and directed by Andrew Van Slee. The story follows a young woman (Krista Allen) who decides to grab the peroxide – the film was originally entitled *Peroxide Blonde* – and change her hair color from brunette to blond, believing that it will enhance her romantic possibilities.

A young nightclub owner, Van (Michael Bublé) already has his sights on her, but she thinks of him as just a friend. She'd rather hook up with a hot-looking volleyball player, Brad (Brody Hutzler). Her friend Liv (Maeve Quinlan) is left alone with Van when Meg runs off with the volleyball player, so she decides to spend time with Van instead.

In the script, the scenes played out sequentially, first the long date between Van and Liv, and then the equally long date between Meg and Brad. After a while, these extensive scenes each began to wear thin. Even with some fun dialogue and engaging situations, coupled with songs performed by Bublé in his character's nightclub, the film needed something to kick it up a notch. It was a comedy, and comedies thrive on energetic pacing.

At this point, the editing deviated from the script. By intercutting the two different dates, it was possible to increase the momentum, contrast the two couples, reinforce the jokes, and further engage the audience. Transition points, moving back and forth between the two dates, were triggered by punchlines to jokes or physical movements, such as a kiss or slamming down a shot glass.

The intercut is an important tactic for writers to keep in mind. Check out some of the masterful uses of the intercut, such as the electrified fence scene from *Jurassic Park* (1993).

In *Jurassic Park*, after a power failure shuts down a nearly completed theme park, releasing its collection of cloned dinosaurs, a visiting

Figure 8.1 Jurassic Park – Climbing the electric fence.
Credit: Universal Studios.

Figure 8.2 Jurassic Park – Restarting the power grid.
Credit: Universal Studios.

paleontologist, Alan Grant (Sam Neill), finds himself fighting to save the lives of two kids, Tim (Joseph Mazzello) and Lex (Ariana Richards). At one point, Grant decides that they must scale the giant electrified fence that surrounds the compound in order to escape the rampaging dinosaurs and find shelter in the visitors' center. The power failure has deactivated the electricity so Grant assumes the fence is safe to climb. What they don't know is that two other scientists, Ellie (Laura Dern) and Hammond (Richard Attenborough), are working to restore the power – an awesome and frightening scenario.

Hammond radios the reboot instructions to Ellie. She locates the junction box and begins the process of flipping one enormous circuit breaker after another, while Grant, Tim, and Lex begin to scale the fence. At this point, the scenes cut back and forth between the fence and the basement, where Ellie struggles to restore the park's electricity. This intercutting between Grant and the kids trying to make their way to safety and Ellie and Hammond's attempts to restart the power grid keeps the audience on edge throughout the sequence. As the editing tightens, and each party gets closer and closer to achieving their goal, the tension increases.

In the case of *Jurassic Park*, the writers, Michael Crichton (novel and adaptation) and David Koepp, anticipated this tactic and wrote the intercutting into their script.

```
EXT. JUNGLE - DAY

GRANT, TIM and LEX scramble through the jungle,
completely out of breath, exhausted. Grant
practically drags them up the last hill, but
they make it, and collapse at the base of
the big electrical fence that surrounds the
compound.

Grant looks up at the fence. It must be over
twenty feet high. He looks at one of the
warning lights on the fence. It's out. He picks
up a stick and pokes the wire. No sparks fly.

Still not trusting the fence, he pokes it with
a finger. He lays both hands on a cable and
closes his fingers around it. Nothing.

                    GRANT
          Power's still off.
          It's a pretty big climb,
          though. You guys think you
          can make it?
```

 TIM
 Nope.

 LEX
 Way too high.

Far in the distance, the T-rex ROARS. Without a
second delay, both kids leap to their feet.

EXT. PATH - DAY

ELLIE and MULDOON step onto the path that leads
through the jungle toward the maintenance shed.
The gate CLANGS shut behind them, making them
both jump.

(Along the way, they encounter a raptor and barely get away from the
creature before they shoot a hole in the maintenance shed and enter.
From here, the action returns to the jungle.)

EXT. JUNGLE - DAY

A hand comes into the foreground and takes a
firm grip on the tight fence cable. Another
hand follows it, then a third.

GRANT, TIM, and LEX climb over the fence,
pulling themselves up by the tension wires,
crawling right past a "DANGER!" sign that tells
them this fence ought to be electrified.

 CUT TO:

INT. BUNKER - DAY

MALCOM and HAMMOND hover over a complex diagram
of the maintenance shed that's spread out in
front of them. Hammond clutches the radio in
his hands, almost praying to it. Finally, it
CRACKLES.

 ELLIE (O.S.)
 I'm in.

INT. MAINTENANCE SHED - DAY

```
ELLIE is at the doorway of the maintenance
shed, breathing hard from fear, listening to
Hammond's VOICE on the radio.

              HAMMOND (O.S.)
         Okay - straight ahead
         there's a metal staircase.
         Go down it.

Ellie does, heading down into the room,
shining the flashlight ahead of her. There is
a maze of pipes, ducts, and electrical work on
both sides of her.

EXT. JUNGLE - DAY

GRANT and the KIDS are now near the top of the
fence. A warning light, next to Grant's hand,
is still out.
```

The action continues back and forth for a couple more pages, with each party trying to remedy the situation while unknowingly risking lives in the process. The sequence's tension continues to escalate as the scenes intercut between two conflicting goals – Grant's desperation to get them all safely on the other side of the fence and Ellie's attempts to turn the system back on, which would electrocute the others, without her knowing it. It's a perfect combination of conflicting desires, all woven together by the juxtaposition of two different scenes.

This kind of intercutting requires clever transitions to transport the audience from one place to another. The family saga *Pachinko* (2022), based on the novel by Min Jin Lee and written for Apple TV by Soo Hugh, uses intercutting to build a complex tale that follows a Korean immigrant family over four generations. The episodes glide back and forth across multiple time periods, starting in 1915 Korea (under Japanese occupation) – where we meet the mother of the story's main protagonist, Sunja (Minha Kim) – and then leaping ahead to a corporate boardroom in 1989 New York to meet Sunja's grandson, Solomon (Jin Ha), ethnically Korean but raised in Japan. In order to secure a promotion with his Japanese firm in Tokyo, Solomon will try to convince a Korean woman his grandmother's age to sell her land for a hotel development. The subtitled episodes weave between the multiple languages employed in the film, from Korean (in yellow) to English to Japanese (in blue). Although unusual, this prismatic effect, achieved by intercutting time and place,

was also showcased beautifully in *The Godfather: Part II* (1974) and, more recently, *Cloud Atlas* (2012).

In order to accomplish the highly complex embroidery of places and times, while maintaining clarity for the viewer, *Pachinko*'s writer and filmmakers designed a wide variety of audio and visual transitions. These incorporated practical camera moves and audio pre-laps, as well as dissolves and straight cuts introduced during post production. In some instances, a straight cut from a close-up of Sunja's young face to a close-up of her elder self served to transport us suddenly across time. In other cases, the camera dollied past a wall, creating a practical wipe from 1915, then emerging on the other side of a different wall in 1986 and then back again to 1915.

Many of these transitions were conceived in the script stage, including the one that bridges the opening scenes (below). Ultimately, it wasn't used since the filmmakers chose to begin in 1914 Korea – a more intriguing and tonally significant place to start – rather than 1989 New York.

EXT. SIDEWALKS OF MANHATTAN, NEW YORK CITY - DAY (**1989**)

The Greatest City in the World, looming with skyscrapers that shoot up into the skies like commercial cathedrals paying homage to Man's Prodigy. But here, on the ground, the MORNING CROWDS flood the sidewalk. A sea of white faces, washing over Wall Street like a prodigious wave. But gradually, one face starts to stand out …

SOLOMON BAEK (28, Korean). Despite being the only ASIAN in this canvas of WHITE FACES, or perhaps because of it, this man holds his own. His confidence - a force to be reckoned with. And as he plows past our camera -

CHYRON: **NEW YORK, 1989**

We begin to glimpse another figure approaching - A KOREAN WOMAN dressed in the traditional hanbok. No one else in the crowd seems to spot her. Only us, marveling at this discombobulating figure who stands very much "out of time" here. And as we PUSH IN on her face, isolating her in the frame, the music abruptly stops, and we -

```
SLOW DISSOLVE TO:

EXT. TAEJONGDAE FOREST, YEONGDO ISLET, KOREA -
EARLY MORNING (1914)

From that world of stone, concrete, and steel,
we jump to the poetic rustlings of green
treetops turning to fall orange, rendered in
delicate brush strokes. A world seemingly
devoid of any unnatural materials.

Here, we find the same woman from our
cityscape - YANGJIN (18) - halting suddenly to
stare at a tiny hut cloaked in trees.
```

In the final released version, the order is reversed. And titles were added at the beginning to establish the historical context:

In 1910, Japan colonized Korea as part of its growing empire.

Under Japanese rule many Koreans lost their livelihood, forcing many to leave their homes for foreign lands.

Despite this, the People endured.

Families endured.

Including one family ...

From one generation to another.

As the titles fade to black, sounds of nature fill the screen, then cutting to a young woman (who we'll recognized as Yangjin, the protagonist's mother) standing in the midst of a forest, gazing toward a distant hut.

An audio downbeat heralds another, larger title: JAPANESE-OCCUPIED KOREA 1915. Rather than following Yangjin's walk to the hut and then interrupting it with a cut to another New York City scene ending with pre-lapped dialogue ("My mother was not a fortunate woman ..."), as in the script, the action jump cuts directly to the interior of the hut:

```
INT. THE HUT, YEONGDO ISLET, KOREA - EARLY
MORNING (1914)

In the one-room abode, Yangjin is kneeled in
front of the MUDANG (the Shaman) - as old as
time itself - along with her CHILD ASSISTANT.
```

> First forced into the realm of shadows by the
> Joseon Dynasty and further marginalized for
> being "too Korean" by the Japanese, the Mudang
> now sits crouched small. But in desperation,
> Yangjin offers her story:

YANGJIN

*And my birth was a great burden to her. She
died when I was very young, and my father - in
his grief - took to drink -*

The dialogue is slightly revised in the released version: "My mother was not fortunate. And my birth was a great burden to her. She died when I was but a child. In his grief, my father took to drink ..."

She tells how her father offered her as a bride to a kind boy with a cleft lip in Dongsam. In her meeting with the shaman, she asks that a curse be lifted, and several years later she gives birth to the story's main female character, Sunja.

The scene ends with, "I am with child. There's a curse in my blood," leading to a slow dissolve, like ghosts churning over her image, that takes us to the crowded New York City streets in 1989. The contrast is striking.

We finally meet Solomon, tracking with him into a modern office building and upstairs to a conference room where he's told by the higher-ups, "Listen, there's no easy way to say this. You're not getting the bump." This motivates him to prove himself and win over his bosses by securing a coveted piece of real estate in Tokyo, where one landowner is refusing to agree to sell.

As we will see again and again, the value of intercutting is the essence of film editing and, consequently, is an effective approach for the writer to employ. Remember, a screenplay is not the final work. It is a story told in pictures, and the writer's job is to keep in mind the power of juxtaposing images and scenes to add interest, nuance, and deeper meaning to the story as it plays out.

Point-of-View

Who's watching the scene? Why this character and not someone else? Is there a point-of-view? Without a point-of-view, a scene feels untethered, free floating. The action has fewer consequences and less at stake. Who is this person who is witnessing the action?

Action scenes are particularly prone to this conundrum. In a presentation to USC's School of Cinematic Arts,[5] alum Ryan Coogler (*Fruitvale*

Station, Black Panther) made the all-important point that action scenes are not only about exciting stunts, stunning effects, and thrilling action. Most importantly, like everything else in storytelling, they are about character.

In trying to service the excitement of a battle, a chase scene, or other dynamic action, directors and editors can get carried away with the spectacle of a scene and lose track of the characters. It's important to always keep the main character in mind and remember the dramatic need that drives them.

Editor Joe Walker echoed the primacy of character in relation to the wildly visual and auditory experience of *Dune*. Here, a world that doesn't really exist becomes stunningly believable through accomplished production design and careful editing. "It doesn't matter how great the world building is. If you don't care for the central character then we might as well go home," said Walker.[6]

Character drives plot and influences the audience's identification with the story. Scenes need the human quality that connects the audience to the events unfolding before them. Without insights into the characters, the action becomes as dazzling, but ultimately as empty, as fireworks.

In *Dune*, a film of extraordinary action sequences, Walker understood the importance of knowing when to let an actor's moment play. The audience needs to be able to look into the character's eyes and feel something.

Notes

1 "The Whole World Is Watching: Inside Aaron Sorkin's The Trial of the Chicago 7." Netflix. February 24, 2021. www.youtube.com/watch?v=6Q6eCLk0XLs
2 Promotional interview for awards consideration. Netflix.
3 Aaron Sorkin in conversation with Rob Lowe. American Cinemathque/Gwen Deglise. March 5, 2021.
4 The editing triangle consists of selection, length and juxtaposition.
5 "Q&A with Ryan Coogler." USC School of Cinematic Arts, Eileen Norris Cinema Theater. June 6, 2018.
6 Huffish, Steve. "The Art of the Cut, Ep. 135. 'Dune' Editor Joe Walker, ACE." October 27, 2021. Anchor.fm/frameio-insider

9

THE ESSENCE OF TIME

The chapter explores time as a crucial factor in film: how it is created in the script and supported by the final cut, and what happens when time factors are neglected in the script. Montages, often discovered only at the editing stage, can be designed while writing the script and allow the compression of time and the minimalization of non-dramatic sequences.

The act of making a cut alters time. Look at the high speed transitions through time, multiple universes and life paths in *Everything Everywhere All at Once* (2022). In film, time moves in many directions and at different speeds. These varying velocities mirror our psychological perception of time rather than following the linear clock time that we live by. The artist Andy Warhol once made *Sleep* (1964), a film documenting the poet John Giorno (who was also his lover) sleeping for 5 hours and 21 minutes. This represents an extreme example of a very slow passage of clock time. Film time, on the other hand, gives the impression of time's passage without accounting for every second. It is time as feeling.

Thoughts of the past and future bring anticipation, stress, and joy to human life. The burn one feels when performing intense physical exercise can feel a lot longer than the delight of a kiss, a chocolate chip cookie, or a warm bath.

Unlike animals, who Rilke reminds us "see the open with their whole eyes,"[1] humans, with our crowded minds, spend time in past regrets or future worries. The mystic's suggestion to "be here now"[2] is often easier said than done. In practice, it is hard to stay in the present, even though that is the only reality. Movies create an artificial present that captivates us for the duration of the film but then releases us back into our world of concerns when it's over.

DOI: 10.4324/9781003161578-10

The essence of drama is conflict. Editors and writers build this conflict into the construction of scenes. Those aspects that make life pleasurable or painful are what bring stories alive, allowing them to thrive and find satisfying, though not necessarily happy, conclusions.

There is often a **ticking clock** where the hero or heroine must achieve a goal before time runs out. When that isn't apparent in the footage, an editor will introduce intercuts to add intensity or time pressure. Failing that, they may request additional material in the form of pick-ups. In the case of an action thriller that had a rather light-hearted and unfocused beginning, we added a short chase scene at the beginning. The main character was pursued by an unseen assailant who would eventually reappear.

In another instance, for a teen comedy about a cheerleading camp, we added scenes of competition in order to raise the stakes and make the action more engaging. For writers searching for a way to up the ante, it can help to add time constraints, pursuits, or competition.

Christopher Nolan's films often talk about the confounding and malleable concept of time. In editing these films, he takes advantage of film's ability to alter time, cutting back and forth through past, future, and present. *Memento* (2001), edited by Dody Dorn, ACE, moves backward and forward through time. *Inception* (2010) accelerates and then reverses the flow of time. *Tenet* (2020) jumps forward and then back. And, even in the midst of stated, and sometimes confusing, time bending, some of *Tenet*'s most profound intrusions on time appear in traditional management of **film time**.

Film Time: How film editing alters the perceived length of time in a way that is not controlled by clock time.

Toward the end of *Tenet*, we see the digital readout of a bomb counting down, a suspenseful technique that has occurred copious times in film history, whether it is James Bond in Fort Knox handcuffed to an atomic bomb that is about to explode – it is finally defused 007 seconds before detonation – or the ticking clock in Hitchcock's *The Man Who Knew Too Much* (1956). What one discovers upon examining these scenes and others is that clock time has little to do with film time. It may take a minute or an hour for a second to pass by.

Figure 9.1 Tenet – A countdown.
Credit: Warner Brothers.

For decades, editors consistently worked hard to maintain the rules of continuity and object permanence. Today, with the accelerated pace of cinema, it is hard to think of a film that doesn't contain jump cuts. Look at the loading of the tape recorder in the *Trial of the Chicago 7* or the armament montage in *The Convent* (2000). These actions reflect activities that were described in the script and documented during filming but were truncated in editing. As we saw in the first chapter, a writer can take advantage of these editing techniques in the way that Martin McDonagh did in *Three Billboards Outside Ebbing, Missouri* or Taika Waititi in *Jojo Rabbit*.

Writers do well to keep their eyes on the clock. Consider how altering time, either by slowing it down, speeding it up, or rearranging the chronology of events can further engage your audience.

Clock Time versus Film Time

Transition points ground the audience in terms of time's passage. A cut is the basic unit of transition. Within a scene, each cut posits a moment in time. Time can move faster or slower through the scene depending on the cutting style. A prime example of this is found in the adrenaline

injection scene of *Pulp Fiction* (1994), written and directed by Quentin Tarantino and edited by Sally Menke. Here, what is ostensibly a count to three – something that usually takes less than three seconds – transpires in over half a minute owing to the intercutting of multiple shots. In this scene, Vince (John Travolta) is about to plunge a hypodermic needle into Mia's (Uma Thurman) chest with the intention of reviving her from a heroin overdose. Cut by cut, the audience is treated to shots of the participants, the needle, the mark on Uma Thurman's chest, and so on. The variety of images adds to the suspense and extends the actual screen time while still giving the impression that the action took place within a count of three.

This approach was prefigured in the script and expanded upon by editor and director to take advantage of film time.

```
The injection is ready. Lance hands Vincent the
needle.

            LANCE
      It's ready, I'll tell
      you what to do.

            VINCENT
      You're gonna give her
      the shot.

            LANCE
      No, you're gonna give
      her the shot.

            VINCENT
      I've never done this
      before.

            LANCE
      I've never done this
      before either, and I
      ain't starting now. You
      brought 'er here, that
      means you give her the shot.
      The day I bring an
      ODing bitch to your
      place, then I gotta give
      her the shot.
```

Jody hurriedly joins them in the huddle, a big
fat red magic marker in her hand.

> JODY
> Got it.

Vincent grabs the magic marker out of Jody's
hand and makes a big red dot on Mia's body
where her heart is.

> VINCENT
> Okay, what do I do?

> LANCE
> Well, you're giving
> her an injection of adrenalin
> straight to her heart. But
> she's got a breast plate
> in front of her heart,
> so you gotta pierce through
> that. So what you gotta do
> is bring the needle down
> in a stabbing motion.

Lance demonstrates a stabbing motion, which
looks like "The Shape" killing its victims in
"HALLOWEEN".

> VINCENT
> I gotta stab her?

> LANCE
> If you want the needle
> to pierce through to heart,
> you gotta stab her
> hard. Then once you do,
> push down on the plunger.

> VINCENT
> What happens after that?

> LANCE
> I'm curious about that
> myself.

 VINCENT
This isn't a fuckin'
joke man!

 LANCE
She's supposed to come
out of it like -
(snaps his fingers)
- that.

Vincent lifts the needle up above his head in a
stabbing motion. He looks down at Mia.

Mia is fading fast. Soon nothing will help her.

Vincent eyes narrow, ready to do this.

 VINCENT
Count to three.

Lance, on his knees right beside Vincent, does
not know what to expect.

 LANCE
One …

Needle raised ready to strike.

 LANCE (O.S.)
… two …

Jody's face is alive with anticipation.

NEEDLE in that air, poised like a rattler ready
to strike.

 LANCE (O.S.)
…three!

The needle leaves frame, THRUSTING down hard.

```
Vincent brings the needle down hard, STABBING
Mia in the chest.

Mia's head is JOLTED from the impact.

The syringe plunger is pushed down, PUMPING the
adrenaline out through the needle.

Mia's eyes POP WIDE OPEN and she lets out
a HELLISH cry of the banshee. She BOLTS UP
in a sitting position, needle stuck in her
chest - SCREAMING.
```

This highly suspenseful scene uses in-scene (shot-to-shot) transitions to build anticipation through the magic of film fime. But there are also scene-to-scene transitions, which we'll discuss in coming chapters. Included in those are transitions that constitute a montage sequence.

Montages add another dimension of film time. Montages allow the filmmaker to leave out excessive action and dialogue and get to essence of the story. Occasionally, scenes that are fleshed out in a script become montages in the editing room. Why is this? Because those scenes lack the compelling aspects that make for good drama. Yet they need to be there in order to supply essential information and to account for necessary aspects of growth within the characters.

A while back, there was an energetic drone shot of a bowling alley that garnered a lot of attention on Twitter. The camera weaves in and out of the alleys, past bowlers, into the pin loading mechanism, and eventually into the pins for a strike. It's a clever, well-executed shot, but it quickly wears thin without the dialectic that editing and the juxtaposition of shots engender, let alone story with its inherent beats. Travel logs and tour videos can also suffer from this issue. Instead, choosing the highlights and blending them together in a montage often create a more compelling piece.

The slow growth of a relationship or the development of skills involves scenes that appear in a script but are trimmed down in the editing room when they lack enough emotion to supply deep engagement. In these cases, why not start with a montage to begin with?

As a guide, the writer should consider which scenes are absolutely necessary to tell the tale and then survey which of those lack conflict or other dramatic elements. Watching someone exercise, learn to sew, or go out on a date is generally not a compelling experience for an audience. But the activity needs to be included to advance the story. A montage solves this problem. Many scripts, however, arrive with informational scenes that ask to be played out in their entirety. In the editing room, the editor will discover that it is better to move the action along with a montage.

Figure 9.2 Pulp fiction – The adrenaline shot scene.

Credit: Miramax Films.

This relates to the ubiquitous dictum of *show, don't tell* heard in every writers class or group. Generally, the montage's advantage resides in showing rather than telling.

Consider the chess playing montages in *The Queen's Gambit* (2020). At a point, the audience, unless particularly populated with chess aficionados, can lose interest. This is likely when the protagonist easily prevails in every match, up until the final one. But well-edited montages communicate the same information without dissipating the drama or enjoyment. In fact, the audience's engagement is enhanced. Some montages may be quite sophisticated, such as the one in *The Queen's Gambit* "Fork" episode, incorporating visual effects, matte compositing, and upbeat music to show the long path to arrive at a showdown between the two main competitors, Beth Harmon (Anya Taylor-Joy) and Benny Watts (Thomas Brodie-Sangster).

To jump directly into the final competition would have diminished the stakes of the match and left the audience feeling cheated. Yet playing through each of the previous competitions would have made for an unwieldy and less involving show.

It is inspiring to note that the writer of *The Queen's Gambit*, Allan Scott, took 30 years, rewriting and re-submitting his script, until it was finally produced and became the most viewed show on Netflix at that time, with 62 million viewers.

In other cases, an encounter needs to play out step by step, as in the challenge to Prince T'Challa (Chadwick Boseman) in *Black Panther* (2018). Here, each move is choreographed, starting with various tribes of Wakanda voicing their support for the prince who will become king. But there is one holdout, M'Baku (Winston Duke), who insists on a physical challenge to the throne. As the fight escalates, our hero initially has the upper hand, but the script rightly calls for the competitor to gain an advantage, beating him with head and fists, until it is not clear who will survive.

By the end of the scene, on the edge of a waterfall, the prince finally prevails and shows mercy to his opponent. His bravery, strength, and compassion make him the person whose story we want to follow. To have structured this sequence as a montage, leaving out the details of the conflict, the nail-biting twists and turns, would have diminished the scene's strength and lessened Prince T'Challa's victory and his accompanying mandate to rule.

Figure 9.3 Queen's Gambit – Chess competition montage.
Credit: Netflix.

Figure 9.4 Black Panther – The battle at the waterfall.

Credit: Marvel Studios/Walt Disney Pictures.

As challenging as it is for humans to face an unknown future or make peace with a bygone past, film stories use this most basic of conflicts to tell compelling stories. For the writer who juggles time, it's important to determine when to slow down and let a scene play out, when to jump ahead, and when to move forward at an even pace. Whichever approach best serves the scene, it will play for the audience not as a manipulation of time but as the only possible way that the event could have transpired.

As we'll see in the next chapter, one of the most powerful uses of time occurs when creating filmic moments. Here, the characters are suspended in time and gripped by intense emotion.

Notes

1 Rilke, Rainer Maria. *Duino Elegies.* Translated by C.F. MacIntyre. University of California Press, Berkeley. 1965.
2 Dass, Ram. *Be Here Now.* Harmony/Crown, New York. 1971.

10

THE FILMIC MOMENT

Another aspect of the time equation is the creation of filmic moments in the editing room. This chapter explores plot and theme as catalysts for filmic moments and speaks to how writers create powerful, emotional moments.

One of the great hurdles in screenwriting comes in creating emotionally rich moments. These moments can arrive with or without dialogue. They might be captured in a look, an interruption of time, an unexpected image. Many **filmic moments** are subtle, so the supporting images might not present themselves immediately. They must be discovered or ferreted out.

 Filmic Moment: A period of time where the story's overall theme is heightened by a brief but intense interaction between the characters, anchoring them to the present. In these moments, time seems to slow down.

At times, the creation or reinforcement of these moments depends on the editor's approach to watching the dailies and remaining receptive to what is seen there. As mentioned before, there are two basic ways to evaluate dailies. The first we'll call the director's approach, which is based on the original shooting script. Through shot lists and blocking, the director seeks to accumulate the footage that will answer the requirements of the script. This consists of all the angles that best cover the action and dialogue. Along with this comes the actors' skills in delivering the lines and

DOI: 10.4324/9781003161578-11

evoking a feeling. Ideally, the daily coverage will eventually satisfy every requirement posed by the script.

The other approach is the editor's approach. In this approach, the editor's actions are based not on the wish list of the shooting script but on the dailies themselves, which may be mirrored in the script supervisor's script. For the writer, it is instructive to follow the path of the dailies and see how they have altered or reinforced the script.

Filmic moments can grow out of both of these lines of attack. In one, the editor seeks out the moment; in the other, the elements are presented to the editor. It could be a turn of the head, a roll of the eyes, the tilt of a hand that imbues a once simple scene with deeper meaning. Or it may be the excavation of a missing link, the neglected motivation for the entire scene.

Some of the clearest manifestations of filmic moments occur in scenes of attraction or loss. Each cut draws the audience deeper and deeper into the intimate world of the characters, whether in public or private. The characters' experience of each other glides back and forth, allowing the emotions to grow and eventually blossom.

Writer/director James Savoca (*The Crooked Corner*), feels that

> it is my job to create the most exciting moments possible. A film is made up of scenes, which are made up of moments. A scene without an interesting moment will simply fall flat. A moment is where we the audience engage with the characters. It is how and why we feel for them. If you say to me "Casablanca" I don't think *story*, I think *moments*. I actually see them – the moment Rick is left alone after Ilsa's late-night visit. The burning cigarette, the fallen whiskey glass and Rick's watery eyes. This moment in time is where I connect with Rick and am forever on his side, through the ups and downs, I watch and root for him all the way.[1]

An example of a powerful filmic moment of attraction is found in the subway scene of Steve McQueen's film *Shame* (2011). *Shame* is the tale of Brandon Sullivan (Michael Fassbinder), a Wall Street sex addict, whose cavalier adventures are impinged upon by the arrival of his sister Sissy Sullivan (Carey Mulligan) for an unexpected and extended visit.

Figure 10.1 Shame – Brandon and a stranger encounter each other on the subway.
Credit: 20ᵗʰ Century Studios.

In this scene, Brandon is riding the New York subway alone when his eyes connect with another passenger, a young woman seated across the aisle from him. The scene begins with an out-of-focus close-up of Brandon, then a cut introducing the slightly wider shot of the young woman. They exchange looks.

She glances at him, then looks down and then up again in a coy, flirty manner, her lips forming a faint smile. The camera lingers on her, longer than a casual glance would invite. Her eyes flash again.

The next cut is also a sustained shot, again of Brandon, his expression unaltered, Kuleshov-like. The only movement is the flashing patterns of light on the tunnel wall outside the train's window.

Then it cuts to another sustained, lingering shot on the young woman, the smile spreading through her, cocking her head, all the while maintaining eye contact.

Back to Brandon, his expression barely altered, shameless, serious. The train stops. His head bobs slightly with the braking.

Back to the woman. She appears aroused, she shifts her head in an inviting manner, her tongue tracing her lips, her eyes holding on him. Her chest lifts in a sigh. Her eyes gaze downward, trancelike, as her head lulls back against the wall. She seems taken away. The cut continues to hold on her. She looks off dreamily. The train jerks, begins to move again.

Cut to: Brandon, holding his gaze, but now in a tighter close-up. Up until this moment, their shot sizes and composition haven't changed, but now the angle has grown more intimate on Brandon.

The next shot reveals her hands resting in the crease of her short skirt as it folds between her legs. One leg crosses protectively over the other. The fingers twist slightly, then the camera tilts slowly up to her face staring daringly at Brandon. Her lips part.

A cut returns us to the neutral close-up of Brandon, unwavering in his gaze.

Then back to the woman in a slightly wider shot, a look of sadness seems to eclipse her. Or maybe it's resignation. Maybe both. She looks up as if making a decision and stands, crossing to the center pole, her hand grasping it and revealing – a wedding ring. The shot holds until another hand reaches in and grasps the bar below hers. It's Brandon's hand, and his dark cloaked form obscures half the frame. Still on the same shot, the camera tilts up to find a two-shot, in profile, of Brandon and the woman, with the subway car and other passengers in the background. Not a word has been spoken. The music rises with emotion. Their eyes flit lightly without ever looking at each other.

Then, as the train slows again, still in the same shot, the young woman steps forward toward the exit. Brandon follows. The camera follows him as he moves through the crowded station and up a flight of steps in pursuit of her. But she's gone.

Finally he stops, glancing around, having lost her. In tight close-up, he looks this way and that, then finally returns to the stairs and heads back down to the platform. The camera holds back and lets him meld into the crowd.

This is a riveting filmic moment. Its true impact derives from both visual and auditory influences: the order and size of shots, the timing and length of each cut, the judicious camera moves, and the music. It's instructive to see how this scene was originally constructed in the script.

INT. SUBWAY. DAWN.

BRANDON sits, looking over at the PRETTY SUBWAY GIRL sitting opposite -

The train moves on, after a while stopping at another platform.

PEOPLE get on, PEOPLE get off.

BRANDON's eyes travel down over the PRETTY SUBWAY GIRL's legs and up -

She opens them a little, the dip of her skirt, sinking deep between her thighs -

She looks up, senses BRANDON watching. She lets her fingers fall in her lap.

BRANDON shifts a little in his seat to get a better look through the crowd. Suddenly she stands and makes her way to the train door. Hand reaching out and clenching a metal pole for stability, revealing a wedding ring.

BRANDON's hand reaches for the pole too, touching her as he stands behind her. There is a gentle unison contact. BRANDON's breath, heavy on her neck. Both are frozen to the spot, caught in a mutual moment.

INT. SUBWAY. MORNING.

The train door bolts open and the PRETTY SUBWAY GIRL disembarks. BRANDON is blocked by a MALE

```
PASSENGER as he gets out in quick pursuit of
the PRETTY SUBWAY GIRL.

BRANDON is several paces behind now, pursues.
She turns left into a stairwell.

It's almost like fighting a downward river.
People are walking into his path as he
struggles to keep pace with the PRETTY SUBWAY
GIRL.

The tail of her coat vanishes at the top of the
stairs. A moment later, BRANDON reaches the
summit, to be greeted by a wrought-iron gate.

He looks left at one staircase. People ascend.
He looks right at another staircase. Other
passengers ascend.

People come in and out of the turnstiles on
the right-hand side. He has lost her. A sudden
moment of disappointment crosses his face.

He descends the staircase, dejected.
```

While giving a sense of the attraction and loss, the script also projects a slightly predatory feel and lacks some of the mutuality of the moment that captivates us in the final cut from the editor, Joe Walker, and the writer–director. McQueen has a masterful command of timing as seen in some of his other films, such as the highly disturbing hanging scene in *12 Years a Slave* (2013).

In the script, the writer's use of all capital letters each time he describes a character's actions, rather than the standard Hollywood way of only using caps to denote sounds or introduce a character gives a sense of the juxtaposition of images, as if we're seeing cuts.

By the end of the film, Brandon has suffered the consequences of his addictive personality and is again riding the subway when he sees the girl from the beginning of the film. This time she is without a hat and her hair is tossed down around her shoulders. Again, an unspoken moment passes between them:

```
At this moment, the PRETTY SUBWAY GIRL stands
up, eyeing BRANDON as she makes her way to the
door, blocking BRANDON as the train pulls in to
her stop.
```

```
INT. PLATFORM. SUBWAY. MORNING.

The train pulls away from the station and
disappears into the tunnel. We do not know if
BRANDON is still aboard or has succumbed to his
urges.
```

In the final cut, this moment develops similarly to their first encounter in terms of shot selection, until we again see her hand with the wedding ring grip the pole in the subway car. But, like the script, the wordless final moment is left equivocal.

What can we take away from this? In dialogue scenes, it's often important to keep the scene descriptions to a minimum. But, in a scene like this, the timing and order of images are crucial. In this case, a writer may consider detailing the actual shots. Most scripts rely on sparse descriptions, expecting that the director and, ultimately, the editor will make those shot choices. In *Shame*, a more detailed description of the interaction occurs. But one can see that even that could have allowed for more details to reinforce the fiery aspect of the scene. The powerful filmic moment that the director and editor achieved shows what other details, albeit brief, might have been incorporated into the script.

The strength of the moments in this film mirrors those in our earlier discussion of the looks in *The Power of the Dog*, where silent glances build emotional suspense. In *The Power of the Dog*, these moments play in a way that is reductive and repelling rather than attractive. In *Shame*, the moments were created through glimpses and careful timing in order to engender a sense of sexual attraction. In *The Power of the Dog*, the looks create anxiety and dread. In both, dialogue is kept to a minimum.

As we can see, most filmic moments require the writer and, subsequently, the editor to slow down and let time and emotion expand. Rather than dispatching the action with a few words, it is necessary to build line after line, shot by shot, until the writer finds the emotion that the moment seeks to engender.

Note

1 James Savoca. Interview with the author.

11

ASPECTS OF DIALOGUE

The chapter explores extraneous artifacts of the original script, the need for clarity in selling a script, how too much exposition can dull the audience's involvement, the redesign of dialogue to incorporate subtext, and dialogue strategies that writers can use from the beginning.

Dialogue and Subtext

Films are not novels. Long and flowery dialogue or highly expository dialogue generally doesn't work well in movies. The dialogue in well-written scripts has a natural flow and simplicity throughout. A character's dialogue generally does not go on for more than a couple of sentences before switching to a response from the other character.

Dialogue is the essence of screenwriting and supersedes description. Like special effects, which don't have to be real, just look real, the same is the case with dialogue. It doesn't have to be real; it just has to sound real.

The most common dialogue scene consists of a conversation between two people. It can be an argument, a decision, a seduction, a reveal. Two-person dialogue scenes are deceptively simple to edit because the coverage, in terms of set-ups, can be minimal. Two over-the-shoulder shots and a two-shot could make an entire scene without the audience feeling a significant gap.

For more spice, a director might include singles – close-ups without anyone else in the frame – and a wide shot. If there's movement, such as walking and talking, a tracking shot will come into play. With these simple elements, the editor can weave a complex tapestry of nuance, misdirects, and emotion.

Action scenes, on the other hand, can consume the entire alphabet of the alphanumeric scene slating system, requiring the use of double letters,

DOI: 10.4324/9781003161578-12

such as AA, BB, CC, and so on, to mark all the coverage. In this respect, one might conclude that cutting action is more complex and challenging. But is it? In action, it's important to keep the viewer on track with what's happening, not confuse them with leaps in time and space (for greater discussion of how geography, temporality, and guideposts influence action, see *The Healthy Edit*), but dialogue offers an equal or greater challenge.

In action, an editor can grab the master shot, plug in a bunch of detailed coverage (such as medium shots and close-ups), throw some music and sound effects on it, and have a serviceable rough cut of an action sequence. This is not the case with dialogue. Dialogue, because it is so akin to emotion and performance, requires exacting moves.

Every word, every eye movement, every pause and breath are exposed. Likewise, in writing dialogue scenes, words that don't ring true, that feel clichéd, that overemphasize information rather than character, that ignore the rhythms of language, fail to engage an audience. Dialogue is hard. A simple confession, a lover's disagreement, a boss's manipulation are, in a sense, more complex than an exploding building, an all-or-nothing car chase, a sword fight.

Dialogue scenes can be laconic or energetic, they can play like a game of chess or like a tennis match – quick volleys back and forth with little room to pause or think. Consider the excellent two-person dialogue scene in *The Social Network* (2010) where the main character, an ambitious Mark Zuckerberg (Jesse Eisenberg) from Harvard, is drinking with his girlfriend from Boston University. Since it is the opening scene, the first dialogue begins over the Columbia Studios logo, with Zuckerberg's claim that "There are more people in China with genius IQs..." This sets the stage for repartee about the value of intellectual elitism and membership in social clubs, of which Facebook will eventually become the most extensive and democratic one in the world.

During the exchange, the two characters remain in place at the table, until the end when they exit. Along the way, something devastating occurs. We witness the disintegration of a relationship. In the end, the girlfriend (Rooney Mara) gets the last word. "You'll think girls won't like you because you're a nerd. But I can tell you..." she concludes in a tight close-up, used nowhere else in the scene, "...it's because you're an asshole."

Aaron Sorkin's evocative writing, along with the tight editing by Kirk Baxter, ACE, and Angus Wall, ACE, propels the scene to its fiery conclusion. Interestingly, the scene contains few dialogue overlaps, with each character given their due before cutting to the next. In writing a scene like this, the writer uses a minimum of scene directions, nothing that interrupts the rapid-fire delivery of the lines.

The scene is stark and simple.

> MARK
> How do you distinguish
> Yourself in a population
> of people who all got
> 1600 on their SAT's?

> ERICA
> I didn't know they take
> SAT's in China.

> MARK
> They don't. I wasn't talking
> about China anymore. I
> was talking about me.

> ERICA
> You got 1600?

> MARK
> Yes. I could sing in an
> a Capella group, but I
> can't sing.

> ERICA
> Does that mean you
> actually got nothing wrong?

> MARK
> I can row crew or invent
> a 25 dollar PC.

> ERICA
> Or you can get into a
> final club.

> MARK
> Or I can get into a final club.

> ERICA
> You know, from a woman's
> perspective, sometimes not
> singing in an a Capella
> group is a good thing?

 MARK
 This is serious.

 ERICA
 On the other hand I do
 like guys who row crew.

 MARK
 (a beat)
 Well I can't do that.

 ERICA
 I was kid -

 MARK
 Yes, it means I got nothing
 wrong on the test.

 ERICA
 Have you ever tried?

 MARK
 I'm trying right now.

 ERICA
 To row crew?

 MARK
 To get into a final club. To row
 crew? No. Are you,
 like - whatever - delusional?

The lines are terse. Almost poetic. And highly evocative – "Dating you is like dating a stairmaster," Erica declares later in the scene, just before breaking up with Mark. Brevity in dialogue is generally to the writer's advantage.

How often does one encounter scripts where the dialogue isn't a line or two but a paragraph? Sometimes more than a paragraph where the writers felt compelled to pontificate and share their message through their hapless characters? Generally, give your characters a break. Write dialogue that sounds like what real people would say. Part of sounding real is allowing for breaths and for the other person's reply. Dialogue that sounds like a person at a party obsessed with their own words, droning

on and on with little interest in the other person, is generally boring, and it will feel that way for the audience.

When confronted with this kind of dialogue, editors will leave out lines or break up the lines to allow for intercuts, pauses, and breaths. Splitting up multiple lines by cutting away to another character helps vary the dialogue's rhythm. There are always exceptions, however, such as Howard Beale's (Peter Finch) long, angry tirades in *Network* (1976). But it took the skills of an extraordinary writer, Paddy Chayefsky, and the engaging performance of Finch to pull it off.

Consider some other excellent two-person dialogue scenes. A clever scene that allows for entrances and exits, uses a variety of angles in the editing, including wide shots, and incorporates multiple overlaps is found in *The Imitation Game* (2014), where Alan Turing (Benedict Cumberbatch) encounters Commander Denniston (Charles Dance) in a job interview. Here, not much is stated directly at first, yet we clearly understand the underlying tension that flows through the scene and between the characters. In this and the following two examples, the power shifts over the course of the scene, and a sort of victory is accomplished by our protagonists through subtext and insinuation, in spite of the challenging personalities they encounter.

Figure 11.1 Imitation Game – The job interview.
Credit: The Weinstein Company/Anchor Bay Entertainment.

```
INT. BLETCHLEY PARK - COMMANDER DENNISTON'S
OFFICE - LATER

A few minutes later, Alan sits alone in a
cluttered office. He stares ahead blankly at
the empty chair behind the desk. Waits.
```

COMMANDER DENNISTON (O.S.)
What are you doing here?

Alan turns with a start.

ALAN TURING
The girl told me to wait -

COMMANDER DENNISTON
In my office? She tell you to help
yourself to a cup of tea while you
were here?

ALAN TURING
No. She didn't.

COMMANDER DENNISTON
She didn't tell you what a joke is then
either, I gather.

ALAN TURING
Was she supposed to?

COMMANDER DENNISTON
For Christ's sake - who are you?

ALAN TURING
Alan Turing.

COMMANDER DENNISTON
(looking at paper on his desk)
Turing … Let me see … Oh, Turing.
The mathematician.

ALAN TURING
Correct.

COMMANDER DENNISTON
How ever could I have guessed?

ALAN TURING
You didn't. It was written on your paper.

Another powerful two-person scene comes from *Hidden Figures* (2016).
In the courtroom, NASA employee Mary Jackson (Janelle Monáe)

116

challenges and ultimately cajoles the judge into allowing her to attend the local high school, which does not allow Blacks, so she can acquire an engineering degree while taking "only night classes."

INT. HAMPTON COUNTY COURTHOUSE - CONTINUOUS

A packed courtroom. NERVOUS DEFENDANTS,
LAWYERS. Way in the back corner, past the sea
of White Folks: Mary sits in "Colored Seating,"
tapping her foot. Finally, A COURT CLERK calls
her name:

 A COURT CLERK
 Mary Jackson. Petition to attend courses
 sat Hampton High School.

Mary hops up. Approaches the rail. A WHITE-
HAIRED SOUTHERN JUDGE looks up from his case
notes. Stops in his tracks when he sees Mary
is … black.

 MARY
 Good morning, your honor.

 THE JUDGE
 Hampton High School is a white school,
 Mrs. Jackson.

 MARY
 Yes, your Honor. I'm aware of that.

The Judge flips through the case notes.

 THE JUDGE
 Virginia is still a segregated state.
 Regardless of what the Federal Government
 says or the Supreme Courts says. Our law
 is the law.

He reaches for his rejection stamp. Mary blurts
out:

 MARY
 Your Honor, if I may, I believe there are
 special circumstances to be considered.

> THE JUDGE
> What would warrant a colored woman
> attendin' a white school?

> MARY
> May I approach the bench, sir?

The Judge considers, waves the BAILIFF to let her through.

Mary walks through the rail gate, stands in front of him.

> MARY
> Your Honor, you of all people should
> understand the importance of being
> first.

> THE JUDGE
> How's that, Mrs. Jackson?

> MARY
> You were first in your family to
> serve in the Armed Forces. US Navy. The
> first to attend University. George Mason.
> And you are the first State Judge
> to be re-commissioned by three
> consecutive Governors.

> THE JUDGE
> You've done some research.

> MARY
> Yes, sir.

Here, Mary makes her case, disarming the judge and achieving her goal, which eventually leads her to an engineering degree and the distinction of being NASA's first Black female engineer.

The direct confrontation of a two-person dialogue scene is one of the most powerful devices in cinema. The challenge that editors often encounter is the need to keep it moving, without extraneous exposition or flowery language, relying at times on reactions, rather than dialogue itself, to reinforce the scene's impact. For the writer, a simple, direct approach with clever dialogue in small doses often fulfills the scene's requirements.

Subtext

Good, meaningful dialogue contains subtext. Subtext reflects an aspect of the way we normally speak, sometimes saying what we mean, sometimes cloaking it in allusions, hints, or abstractions. This meta-communication entices a listener and, in film, an audience to engage with what is said. Dialogue that reveals too much or is too descriptive or reveals the character's exact intentions lacks subtlety and therefore lacks engagement.

When one reads the work of inexperienced writers, one often finds that the expository approach dominates. Characters explain too much. This overexplaining, whether to relate events or to illuminate a character's feelings, diminishes the effect of the dialogue.

How do editors deal with overly wordy dialogue? Simply put, they cut it out. Consider this – subtext in speech is a matter of omission, of excluding direct words or phrases. Of hinting around the subject at hand. A character's dialogue and personality can be improved at times by trimming out a line here or there. In this way, editors foster subtext.

Another way to build subtext is through reactions. In editing dialogue, the question of overlaps comes into play. In an overlap, we see one character's reaction while the other character is speaking. This helps reinforce the subtext. In light of this, writers should consider characters' reactions along with what they say. Let's examine the dinner party scene from the brilliant Mike Nichols comedy *Birdcage* (1996), based on the play *La Cage aux Folles*, where each character has something to hide. Subterfuge makes for excellent subtext.

In anticipation of their kids' upcoming marriage, two families meet – one, the privileged conservative Republican Senator Kevin Keeley (Gene Hackman), his wife Louise (Dianne Wiest), and their daughter Barbara (Calista Flockhart). The other is the liberal, gay, Jewish owner of a drag club in South Beach, Florida, Armand Goldman (Robin Williams), his lover Albert (Nathan Lane), and their son Val (Dan Futterman). A perfect set-up for disaster. Albert has disguised himself as Val's mother to give the impression of a typical American family so as not to alienate the Keeleys. Here's a glimpse at the ensuing tension reflected in the characters' dialogue.

```
INT. ARMAND'S LIVING ROOM

Barbara, Val and Armand are rigid. Only the
Keeleys and Albert are at ease.

          SENATOR KEELEY
     … just so odd to me, this fuss
     over school prayer. As if
     anyone - Jews, Muslims, whatever,
```

would mind if their children
prayed in the classroom.

 ALBERT
It's insane.

Agador walks in with a bucket of ice, sees
Albert and collapses into hysterical laugher.

 ARMAND
Thank you, Agador Spartacus.
You may go.

Agador puts the ice bucket down and exits.

 ALBERT
He's very nice but he's
such a problem! We never
know what makes him laugh.

 MRS. KEELEY
At least he speaks English.
If you knew how many chauffeurs
we've run through in the last
six months …

 ALBERT
If you know how many maids
we've run through in the
last six years. I could name
a dozen: Rodney, Julian, Bruce -

 ARMAND
Oh, look!
 (they turn)
You all need more ice
in your drinks!

He picks up the ice bucket and tongs, and
makes his way around the room, dropping
ice in their glasses.

 SENATOR KEELEY
You know, I really have

such a good feeling about you
people. Not a lot of "clever"
books on the shelves, not a
lot of fancy "art" on the walls
just the crucifix and a lot
of good, warm, family feeling.
This is what Clinton didn't
understand when he started in
on school prayer and gays in
the military …

 ARMAND
And more ice for you …

 ALBERT
Oh, now there's an idiotic
issue - gays in the military!
I mean, those haircuts, those
uniforms - who cares?

 VAL
Now, mom … you shouldn't
be talking about things you
don't know about. Please …

 SENATOR KEELEY
Don't patronize your mother, Val.
She's an amazingly intelligent
woman. I think homosexuality …

 ARMAND
And a lot more ice for you …

 VAL
I'll have some ice, dad.

 SENATOR KEELEY
… is one of the things that's
weakening this country.

 ALBERT
You know, that's what I
Thought until I found out
Alexander the Great was a fag.
Talk about gays in the military.

```
                    ARMAND
            How about those Dolphins!

        They stare at him. He drops the ice bucket.
```

Here, the simple drop of the ice bucket speaks volumes. In the editing of the film, editor Arthur Schmidt built in additional reaction shots, often wordless and usually focused on close-ups of Robin Williams's character. These silent moments enhanced the subtext and the tension created by the sideways dialogue. In both cases, subtext asks the audience to fill in the blanks.

The Sound of Silence

A worthwhile experiment is to substitute dialogue lines with silence. Instead of playing lines that are too specific, the editor simply goes to a reaction. The dialectic of drama, that conflict that drives the story forward, forces the character into situations where they may be ill prepared to respond. The situation is new, whether because they have fallen in love, been attacked, or discovered a secret. Sometimes their dialogue will evade, sometimes it will retaliate, sometimes it will yield. But, as it does, it will inevitably leave out words (as words are thoughts), leave feelings unexpressed, and attempt to manipulate the other character into feeling or giving that which the speaker most desires.

Editors take guidance from this. They decide when to leave the speaker and show the listener, the reactor. The reactor is the other aspect of subtext. These are the overlaps, what some refer to as J and L cuts, that pepper dialogue. By nature, the reactor is silent, listening, responding or trying not to respond. The reactor clues us in to the underlying meaning of the moment, the effect that words and actions are having on the speaker.

In directing a scene, the director often guides the actor through a series of feels – what does the character feel, and what does the character want the other character to feel? In trying to influence their counterpart's emotions, they are also considering what they would want that character to say in response. When an actor is in touch with this, with what they imagine engendering in the other, they have a greater possibility of moving forward truthfully. Not with the lines as written in the script, but with the reality that the lines carry within themselves. These are tied to the goals of the scene. These maneuvers are different from beats, those guideposts along the way that map out exact emotive actions that twist and turn the scene at precise points as it progresses.

Discovering an overall feeling and intention affords a more general approach that the actor can carry with them. What one actor determines to be the feel may be different from how another actor or director would

interpret it. The editor likewise considers the goals of the scene and crafts the scene in anticipation of those moments. In many cases, especially with experienced editors, the actor's goals are intuited. After all, the film has now taken a further step toward completion, leaving behind the tutelage of the script and relying on the performances and shot design that have been concretized in the dailies.

An effective directing exercise seeks to discover subtext in silence, in reactions, as well as in dialogue. In rehearsal, the actor speaks their reaction, filling in the silence with a narrative that reflects what the character is feeling at that particular moment. This helps infuse a performance with meaning and credibility while telegraphing a want or a need that may not be immediately apparent. After the actor has vocalized the silence, they can then go back to the scripted performance.

In this way, it's helpful for writers on one end and editors on the other to imagine how the subtext occurs within reaction shots. It's reminiscent of the way silent films depended entirely on action and response since they were devoid of dialogue. Those that contained a smattering of dialogue (on title cards) still required body language and facial expressions to convey feeling. In crafting a screenplay, writers can consider what might be left out or communicated through an action.

12

DIALOGUE AND CHARACTER ISSUES

The chapter considers pauses and space, the challenges that ensemble characters bring to the writing and editing process, how writers and editors choreograph scenes with multiple characters, and the use of improvisational dialogue.

Space

Other aspects of dialogue editing will also inform dialogue writing. In constructing a film from dailies, the editor strives to remove all unnecessary pauses. Pauses feel like brakes on a vehicle that had been gliding smoothly along. Everything slows. The narrative freezes. Not all dialogue needs to move at the pace of our *Social Network* example, but in some cases too much dialogue and too many pauses hinder the onward flow of the story. This is an issue, for instance, with the use of black. At the script stage, avoid the notation "CUT TO BLACK."

In some cases, cutting to black can be suspenseful, leave us thirsting for the next moment, but, in cases where it is carelessly applied, it erects a blank wall where nothing is happening, thereby pulling the audience out of the experience. This is particularly unnerving in short films where the audience might even believe that the film is over as it fades to black. Black is in a similar category as voiceover. It is something to be included as a last resort rather than at the beginning stage of the process.

In life, filling in all the spaces may not always be preferable. Sometimes, it is important to take time for oneself, step away from the distractions of TV and social media, and immerse yourself in silence. Silence can return us to ourselves. But in film, gaps, if they are not there to build suspense – as in the slow walk downstairs to investigate an unusual noise in the middle of the night – can diminish the energy and power of the story.

 DOI: 10.4324/9781003161578-13

The task of moving characters from one place to another can produce a lag in the narrative. In this case, writers and editors often find that they search to supply dialogue to fill in the long pause. Imagine watching someone just walking up or down a set of stairs. Unless it is a regal entrance (as in Lord Grantham's appearance in *Downton Abbey*) or a particularly clumsy one (as in King Louis's arrival at an elegant ball in *Start the Revolution Without Me*), the mere act of physical transition from one place to another is not very captivating.

Filmmakers use the term **shoe leather** to describe the act of someone walking through a scene, moving from one dynamic moment to another with a plateau of nothing in between. In real life, we're accustomed to seeing people walk or move or climb, so we don't register it. But, in film, too much attention falls on that moment unless the audience is involved with additional information, such as dialogue. In this case, editors sometimes steal dialogue from other parts of the scene to carry over the backs of characters in motion. In this way the silence is filled. The same can occur with long pauses within dialogue. An editor might fill the silence with a distant dog bark, a car horn, thunder, or any other myriad of sounds.

There is another solution, as well, which writers can adopt – cut out the shoe leather.

We are so accustomed to how people get from one place to another that we generally don't need to spend much time on it. The jump cut has prevailed. Movies move and they move faster and faster because audiences have become attuned to the language of cinema. In the writer's case, a simple "CUT TO:" in the transition line may do the trick.

The Ensemble

We've been discussing the most common type of dialogue scene – the two-person scene. But some scenes contain many more players. It's common in these circumstances to ignore at times those who aren't actively engaged, yet their participation needs to be acknowledged for the story's sake so they don't suddenly disappear from the scene. Here, the challenge for writer and editor is to keep everyone alive throughout the scene.

Cinema is full of ensemble stories – look at *Grand Hotel* (1932), *The Magnificent Seven* (1960), or, recently, *The Avengers* (2012), *Guardians of the Galaxy* (2014), and *Justice League* (2017). These are powerful stories, and made all the more so by the participation of an ensemble cast. As the *Justice League*'s logline states, "You Can't Save the World Alone."

But, in each case, it is also important to focus on particular characters. In *The Magnificent Seven* (1960), Yul Brenner's character stands out among the rest of his colleagues. Peter Quill (Chris Pratt) is clearly the driving (or flying) force in *Guardians of the Galaxy*, but each of the other

characters, from Gamora (Zoe Saldaña) to Groot (Vin Diesel), serve valuable roles as well. A danger in ensemble stories occurs when each member seems the same, their personalities undifferentiated, diminishing the overall film.

Figure 12.1 Guardians of the Galaxy – An ensemble cast in outer space.
Credit: Marvel Studios/Walt Disney Pictures.

Additionally, dramas such as *Downton Abbey* or its classic predecessor *Upstairs Downstairs* (1971) rely on a cast of engaging characters. War movies, such as *Saving Private Ryan* (1998) or *The Dirty Dozen* (1967), often assemble a crew of determined fighters. Some Westerns, though ultimately focusing on the rugged individual, can recruit a gang of gunslingers to take on the villains, such as *The Magnificent Seven*, based on Kurosawa's ensemble samurai tale, *The Seven Samurai* (1954).

And horror, with a band of daring characters – often teens or students – allows enough of these intrepid innocents to band together to confront some supernatural terror. Yet the ending often reveals what every editor and writer should understand – only one or two will make it out alive. In *The Convent* (2000), a fraternity of students take a new pledge, along with some sorority girls, a cheerleader, and a Boston terrier, to investigate a 40-year-old urban myth that surrounds a local convent. The convent has been boarded up for decades following the terrible and mysterious events that occurred there. As the college students pursue their adventure, they are picked off one by one by the evil forces that inhabit the building. In the end, only two remain – the good and innocent pledge and his sister.

In *The Magnificent Seven*, as magnificent as all the gunfighters appear, it's only a couple who survive, and only one rides highest in his saddle at the end, Yul Brenner. Those survivors clue us in to the importance of focusing on a central character so that their accompanying thematic purpose doesn't become lost.

In some cultures which give more status to the group than the individual, this exaltation of the hero may appear less pronounced. But in Western culture, as far back as the ancient Greeks, the hero has dominated myths, stories, and fables. American films, in turn, continue to perpetuate the hero myth into modern times and around the world.

The hero allows us to us to identify with an individual like ourselves, but with skills and talents that we may have yet to achieve. In a sense, ensemble pieces are more democratic in that they present a diversity of characters, some of whom may resonate more closely with us than others.

A recent example of a well-handled group scene is the business party in *The Rational Life* (2021), a melodramatic Netflix series that takes place in Shanghai. The series follows a professional woman, Shen Ruo Xin (Lan Qin), who, in her 30s, is considered a "leftover woman." Throughout the series, she navigates the unfair societal pressures of her workplace and personal life, torn between her affections for her bachelor boss, Minjie (Calvin Li), and her young assistant, Qi Xiao (Dylan Wang). She is invited by Minjie to attend a business party. As the dialogue scene unfolds, it splits the characters off into multiple camps including Minjie, the boss, with his male friends drinking at a table, and the women at the bar with Shen.

As the men speak, they inquire about who the new woman is, while the edits keep Shen alive in the background as she waits at the bar where she is eventually joined by other business women. One young woman, Mandy, interrogates her as to whether Minjie and she are boyfriend and girlfriend, while also quizzing her on her credentials and education. The glances between Mandy and her friends tell us that they're not impressed by Shen's pedigree. "Mandy went to Princeton University," one says. "She has a master's degree in literature. Look over there. The one in the champagne-colored dress. She went to the University of Melbourne. She studied art and music. She's really good at playing the cello."

Mandy adds, "In our social circle, one's background is important. I remember Xu Minjie studied MBA at Columbia University."

Shen eventually replies, "I'm not part of this circle," and retires to the restroom to collect herself. Upon returning to the party, she finds a distraught Mandy who's demanding to see the manager because the waitress spilled wine on her dress. In fact, Mandy bumped into the waitress and caused the accident. Shen Ruo Xin enters the scene amid cross accusations between Mandy, the waitress, and the manager as Minjie looks on from his seat. She leads Mandy away from the altercation and helps set things right. The editing and writing work to balance the many characters, keeping even those who aren't immediately engaged alive in our awareness by visual and verbal references.

Scenes involving multiple characters can be dynamic and richly textured, adding richness to a story, but it's important not to lose track of the characters – including those with little or no dialogue – once they've been introduced. Like two-person scenes, these also require subtext in their interactions as well as a need to give each of the primary characters something to do and to say.

Figure 12.2 The Convent – Breaking into the haunted convent.

Credit: Lions Gate.

It is hard to discuss dialogue without considering the characters that it is attached to and the structure that it provides within a story. When considering how to focus a story, the issue of ensemble pieces comes into play. A highly successful ensemble story, *Downton Abbey*, introduces us to an entire estate composed of the upstairs gentry and the downstairs servants including Robert Crawley, Earl of Grantham, his American wife Cora Crawley (Hugh Bonneville and Elizabeth McGovern) and their butler Carson (Jim Carter). We come to see that the privileged gentry are beset with almost as many problems as those who work for them, though of a different nature. And occasionally their issues intersect. No one is immune to suffering, falling in love, experiencing loss or disappointment.

Each character's involvement is essential, yet only a few will stand out above the others. Consider again the earlier party scene example. Not everyone needs to show up, but those who do need enough time to establish their issues and for the writer, director, and editor to explore them.

In *Downton Abbey*, a combination of fluid camera work and well-paced editing guides the viewer through the complexities of characters' lives while keeping each encounter engaging and adding new layers to the plot.

Figure 12.3 Downton Abbey – A lawn party with the Crawleys and Carson.
Credit: PBS.

The challenge that editors face in structuring these sorts of stories is informative for the screenwriter. In the recut of *Joseph's Gift* (1998), a film based on the Old Testament story of Joseph and his brothers, the ensemble issue came to the forefront. The film stars Freddy Rodriguez (*Six Feet Under, Grindhouse*), John Saxon (*Nightmare on Elm Street, Enter the Dragon, The Appaloosa*), and the Bottoms brothers (*Apocalypse Now*), as well as quite a few other characters who make up Joseph's large family, the Kellers. Upon first viewing the original cut, it seemed that it had been constructed rather well. The cuts flowed seamlessly together; one scene transitioned easily to another. But it was boring. Unengaging. Weighed down by the number of characters. Even though the overall material was well directed and well shot.

One of the first issues that became apparent upon viewing it again was that it lacked focus. The viewer became mixed up in the crowded family of characters. After a prologue that exposed us to a cataclysmic fire at a Los Angeles garment factory, the story jumped ahead to a family dinner at the Kellers' estate. One by one, family members arrive until the tardiest guest – the youngest son, Joseph (Freddy Rodriguez) – appears. The dinner begins, and the patriarch, Jacob Keller (John Saxon), announces that he's appointing Joseph to a plum position in the family business, something the other children had to work for. Amid a chorus of protests from his other sons, the father defends his decision and, holding up a headline, reminds them of the tragic fire at a competing garment shop.

As in the Old Testament story, the jealous brothers conspire to get rid of Joseph, in this case by taking him on a business trip to New York and

having him committed to a mental hospital. In the opening scenes, however, it was unclear whose story it was. The other family members played important parts in Joseph's sufferings, and it was important to meet them and learn their motivations.

The first cut introduced many of them through wide shots at the dinner table. In recutting, the first thing to do was to move into close-ups so we could recognize them. But the most important editing move was to keep returning to Joseph, showing his reactions, even if his lines of dialogue were fewer than the other brothers. In the script, everyone was given fairly equal treatment, and the camera and editing had followed suit.

Another discovery that helped in the re-editing of these early sequences was something that was revealed much later in the story – Joseph has the gift of prophesy. In this case, since this was a modern version of the story, he foretells the collapse of the stock market, thereby proving his worth to his boss, played by Robert Townsend, and convincing him that Joseph should be running the company.

Figure 12.4 Joseph's Gift – Joseph dreams a vision of disaster.
Credit: Alpine Pictures/TBN.

In the case of *Joseph's Gift*, a perfectly effective entry point became clear. It involved stealing footage from much later in the film – a simple medium shot of Joseph asleep on the bedcovers of a neatly made bed in

the hotel he and his brothers visited on the fateful trip to New York. What made the shot significant was that it could be played as a luxurious bed in the upstairs bedroom of Joseph's family estate, instead of the hotel bed as originally intended. Since the shot was fairly tight there was nothing on the walls or surrounding furnishings to give away the fact that it was a bed in a hotel room and not in a family home. Adding this shot before the dinner scene turned the scene that preceded it – the sweatshop fire – into a premonition, a vision, a dream state rather than simply the recounting of a terrible event.

Joseph, taking a short nap, daydreams while fully clothed and lying on a neatly made bed before dinner, and sees beyond time and space. By cutting into a tight shot of his sleeping face and adding the ticking of a clock that morphs into the sounds of the sweatshop, I was able to transition into the scene. Then, upon the brash sound of the alarm clock, I cut back to Joseph waking up, ostensibly overcome by what he has just seen.

This footage allowed for the creation of a mini scene that could bridge from the tragic fire at the illegal sweatshop to the dinner of the privileged garment business family. It was the kind of scene that could have been included in the original screenplay and greatly benefited the story. In this case, however, the need for it only became apparent at the editing stage.

The shot established our main character, as well as establishing his unusual abilities. Its importance and effectiveness meant that the shot couldn't be used later in the film, but it turned out we didn't need it. There were other events and dialogue that encompassed the hotel room scene with the brothers. Also, audiences don't tend to have memories as good as we fear they might. A shot that occurs several scenes before may not register if used again, unless it contains a unique image. One sees this often in terms of continuity issues, where a misplaced object or position may not be noticed when it occurs a couple of shots later.

In this simple rearrangement, the story's opening evolved from an unfocused ensemble piece to the tale of a conflicted young man with a peculiar talent, in search of truth and liberation from his abusive brothers. By allowing Joseph to be the first person we focus on, and then coming back to him again and again in the dinner and dessert scenes, I placed him clearly in the audience's sights.

It's amazing the power of a single cut to alter an entire film. It can leave out inessential or confusing information. It can alter time. It can draw a connection between two previously unconnected ideas or feelings. It can change meaning. It can alter story. And, in doing so, it shows us the possibilities that might have been realized at the script stage. This is why every step counts.

A horror film that prospered on the drive-in circuit during the pandemic, *Murder in the Woods* (2017), was written and directed by

Luis Iga as an ensemble piece. In it, a bunch of teens go to party and spend the night at a cabin in the woods. What the director and editor discovered upon viewing the film at the rough cut stage was that the movie felt too even-handed in its treatment of all the characters. No one stood out as the person to watch. Eventually, the audience came to learn that the story's primary conflict arose from a trauma experienced by one of the characters. This awareness led the filmmakers to refocus on the main characters, a particularly good idea since the others would be killed off in the interim.

Of course, too much focus can telegraph who is dispensable and who is not, and so it was important to give each character their due, while also deciding whose story it was. In doing so, certain characters moved to the forefront.

According to Iga,

> Every film gets written three times, script, principal photography and editing. Initially during the editing process the film seemed to be more of an ensemble piece and the throughline of our main character (Fernanda) wasn't as clear. My producing partner/ writer and I, we went scene by scene analyzing what each scene was about, making sure we could see her more and also see her POV. We cut the fat that was not accomplishing this. We also focused more on the love story between Fernanda and Jesse. We were able to build a clear arc and see her grow from a goody-goody scaredy cat to enjoying the party to falling for Jesse to tak-ing control of the situation and becoming a leader. In addition, we were looking for ways to have the audience ask more ques-tions and to keep them guessing, so we planted the flashbacks of Jesse as a kid throughout the film.[1]

Foreshadowing: Along with giving information about a character's current state, dialogue can foreshadow events and emotions to come. Foreshadowing, such as this, is an important part of storytelling, particularly when the audience encounters events, emotions or ideas that are out of the ordinary. Foreshadowing is a great friend to writers and to editors. It adds believability to a story and also imbues the audi-ence with a sense of power that they initially don't know they have – insight. When the event or truth that has been foreshad-owed is finally revealed, its satisfaction for an audience is one of the great enjoyments within storytelling.

Improvisation

A writer will work for hours, days, years to fashion dialogue that reflects the characters in a skillful and expedient manner. As has been pointed out, the dialogue doesn't have to be real; it just has to sound real. In fact, it is better if it isn't real, since real dialogue tends to expand to great lengths, lack poetic or artistic phrasing, and drift from the subject at hand.

That is the risk faced by asking or allowing actors to improvise their own dialogue. Skilled actors who understand their characters may be able to summon sentences that approximate what their characters would say. Less skilled actors don't come close. Either way, it is left to the editor to pick and choose the best lines. In some cases, the improvisational approach works splendidly, especially in comedies where you have a talented comedian who is accustomed to improvising. Robin Williams comes to mind. Or Eddie Murphy. Or, recently, Bo Burnham. In other cases, the editor must slice and rearrange words and sentences to create the desired effect that would probably have been better achieved by sticking to the script.

If one is to go the route of improvisation, it is a good idea to shoot the dialogue as scripted and then allow for separate takes where the actor improvises. As natural as good films appear, most arrive at that point by careful attention to craft and timing. Without that, it takes the risk of pulling the audience out of the picture.

An editor who is confronted with improvised dialogue has to address several issues. First, improvised dialogue tends to run long, so words must be eliminated and streamlined. Second, improvised dialogue often lacks the meta-communication that a well-crafted line will contain. The editor needs to find a way to create subtext by leaving out certain obvious or on-the-nose speech. And third, the rhythm that writers bring to dialogue needs to be sculpted from the improvised, sometimes meandering, chatter.

Julius Epstein contends that

> most natural dialogue is awful. You can't do that in novels, the stage, screen, bar mitzvahs, or anything. You can't use the natural way people talk. You think people talk like Woody Allen talks? They don't. That's what happens when you have improvisation. You're down to the lowest common denominator.[2]

To write dialogue takes great skill, requiring the writer to listen to the way people speak and, also, the way they don't speak. This is perhaps the most important aspect of writing dialogue. In that way, the dialogue must telegraph meaning without stating it.

Good improvisational dialogue must be linked to the character's dramatic need, which can include evasive language as well as dialogue that directly addresses an issue. Attending to the dramatic need helps bring structure to less structured dialogue. But actors may not hold to that need in the way a screenwriter would, so it remains incumbent upon the editor to craft the improvised dialogue so it leaves out extraneous chatter and holds to the writer's main throughline and intentions.

Voiceover

This also raises the question of voiceover. In the documentary world, where the conversational dialectic is usually non-existent, the question of voiceover is often raised. The same applies to some narrative films where clarification of details becomes necessary. Consider again the opening voiceover in *Pachinko*.

Voiceover is the most direct exposition possible. Rather than cloaking information in dialogue, voiceover states it directly. Sometimes that works well, when narrated by the main character expressing their point-of-view in an idiosyncratic way, such as the wonderful voiceover in *American Beauty* (1999) where the main character recounts some turning points in his tortured middle-class life leading up to his early demise.

In *The Shawshank Redemption* (1994), the character of Red (Morgan Freeman) narrates some of the action in a highly effective way. Yet, as written, the director and editor realized that at times the voiceover was superfluous and could be jettisoned. Even though it read well on the page, once filmed, the need for some of the explanations faded away. Writer–director Frank Darabont described how it was

> a great example of something reading just fine in the script, but really not working on film. When editor Richard Francis-Bruce first cut this scene together, he added Red's voiceover as specified. The result was utter confusion. You were seeing one thing, listening to another, and completely unable to concentrate on either since the two stories didn't relate at all.[3]

Generally, it's best to avoid voiceover unless absolutely necessary. When considering voiceover, first try writing the scene, whether fiction or non-fiction, without voiceover. Let the characters, interview subjects, or actions speak for themselves. Then view it. At that point, if there are information gaps that voiceover can solve, it might be the right time to incorporate it.

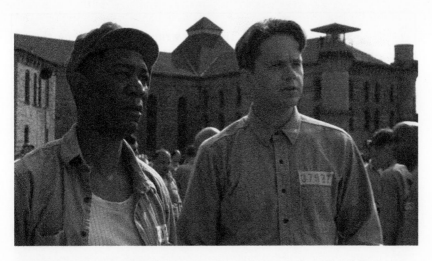

Figure 12.5 Shawshank Redemption – The narrator, Red, and his fellow inmate (Tim Robbins) in the prison yard.

Credit: Columbia Pictures/Castle Rock Entertainment.

For Editors: Voiceover is another form of exposition, of telling rather than showing. If the audience wanted to have the story explained to them, even if in lovely poetic language, they might do better to read a novel. As such, screenplays need to provide the building blocks to get to the next step. In the editing room, it is often best to communicate information through images and dialogue before resorting to voiceover. This includes the documentary genre as well as narrative fiction. Voiceover can be a crutch in a similar way as music. Put a terrific score on even the most lackluster film and it will play better. In cases of music and voiceover, editing dry is a better tactic. It requires the editor to bring the film as far along as possible without any added help. Controlling the pace and rhythm, providing smooth transitions, and promoting clarity fall first to the editor. Once the film is working on its own, editor and director can review it to see if there are gaps in information and emotion that need to be filled in by voiceover and music, respectively. At that point, the addition of these elements can lift the film to a whole other level. It will feel organic rather than contrived and artificial. A writer can take heed from this as well. Stick to the bare bones at first; get the rhythm, clarity, and transitions right before looking elsewhere.

For Writers: Try this – write a dialogue scene, then cut out any dialogue that specifically states what the scene is about, anything that directly explains the characters intentions, ideas, or motivations. Discover the scene's meaning through nuance, implication, and suggestion.

Notes

1 Luis Iga Garza. Interview with the author.
2 Hunter, Lew. *Naked Screenwriting*. Rowman & Littlefield, Maryland. 2021.
3 Darabont, Frank, and Stephen King. *Shawshank Redemption: The Shooting Script*. Newmarket Press. September 30, 2004.

13

WHEN "CUT TO" ISN'T ENOUGH

Most scripts use a simple phrase such as "cut to" or "dissolve to" to denote a transition. Transitions can be shot dependent. This chapter looks at how editors design scene-to-scene transitions and the writer's opportunities to prefigure transitions during the script stage.

Transitions

In the past, screenwriters often ended a scene with a CUT TO or DISSOLVE TO direction. Today, the CUT TO is often assumed unless the writer feels a need to emphasize a transition in a declarative way, such as "I'm not going to sleep with you" CUT TO: They're in bed together.

The notation DISSOLVE TO implies a more gradual and often lengthy time transition. In a dissolve, the incoming scene slowly superimposes itself over the outgoing scene until only the new scene remains. As a time transition, it could span days, weeks, or years from the scene that precedes it. If one looks at films from the forties, the tendency to dissolve from scene to scene predominated. But all those dissolves impinged on the film's pace. As audiences became more film savvy, by the sixties most dissolves were left out by editors. Today, it is rare to see a dissolve transition written into a script, unless the writer is describing a montage.

Transitions relate to rhythm, an essential quality. Director David Lean (*Lawrence of Arabia, Doctor Zhivago, Ryan's Daughter*) began his career as Editor David Lean. His films succeed partially because of his command of editing and, specifically, transitions. Even his early endeavors, such as *The Passionate Friends* (1949), contain elegant transitions. His later works, such as *Lawrence of Arabia*, abound with stunning scene changes.

It's important that transitions coincide in style with the tone of the film. The famous use of wipes in the *Star Wars* films is one example. In many cases, these tools are used to aid the script as it transitions from one scene to another. Consider the clever transitions that were designed for the romantic comedy *Goodbye Columbus* (1969) based on the Philip Roth

DOI: 10.4324/9781003161578-14

novel. In it, a street scene shows the main character's car driving away as the camera tilts down to find the open hood of another car with steam pouring out of the radiator. This scene transitions to a close-up of a steaming pot of peas that his mother is holding in her kitchen. The two images work as a sort of visual pun, tying the two scenes together. Later, the main characters, Neil Klugman (Richard Benjamin) and Brenda Patimkin (Ally MacGraw), tumble into each other's arms and begin to make love on the floor of Neil's apartment. This cuts to a close-up of a slice of rare roast beef that the Patimkin's housekeeper is about to serve at the dinner table. Another visual pun.

Figure 13.1 Goodbye Columbus – Steam transition (a-side).
Credit: Paramount Pictures.

Figure 13.2 Goodbye Columbus – Steam transition (b-side).
Credit: Paramount Pictures.

Food and sex are themes that run through the film. The father, Ben Patimkin (Jack Klugman), eats his way through every scene, and the image of the pot of peas in the lower-middle-class kitchen contrasts with the luxuriant meal of the wealthy Patimkin family in the later transition. In this case, transitions bring meaning as well as humor and rhythm.

In the comedy *Mannequin 2: On the Move* (1991), a young man, Jason Williamson (William Ragsdale), begins his first day of work by reporting to his dictatorial boss, Mr. James (Stuart Pankin), at a grand department store known as Prince & Company. The boss is in the middle of firing the assistant to his store's flamboyant art director, Hollywood Montrose (Meshach Taylor). Hollywood is preparing a grand production re-enacting the tale of a mannequin known as the Enchanted Peasant Girl that has been imported from the kingdom of Hauptmann-Koenig. Unbeknownst to Jason, the mannequin is the petrified form of a cursed young woman from a thousand years ago who will come to life when she meets her true love. In the script, Jason waits patiently to introduce himself to Mr. James.

> After a few beats of silence, James slowly
> turns his head toward Jason.
>
> JAMES
> Now.
>
> JASON
> Uh … Jason Williamson. I was told to
> report to you. New trainee.
>
> JAMES
> Well it seems we've just had an
> opening on
> Mr. Montrose's staff. Follow me.
>
> ANOTHER ANGLE
>
> James walks briskly through the aisles. Jason
> and the assistants have trouble keeping up.
>
> JAMES
> You now work for Prince and Company.
> All I ask is that my employees give
> the same time and dedication to the
> store that I do.
>
> JASON
> What exactly does that mean, sir?

 JAMES
 I have no other life.

 JASON
 Well, then you'll be happy to know
 that I still live at home; I can't
 afford an apartment and I have no
 girlfriend.

 JAMES
 Good. Keep it that way.

INT. STORE AUDITORIUM

A LARGE EMPTY STAGE is being used for a dance
rehearsal.

 HOLLYWOOD (O.S.)
 And … One … two … three.

Up on stage, sticking out from the wings,
we SEE a LONG BALLETIC LEG unfurl - like a
stripper starting her routine. The leg is
followed by a graceful arm, the hand waving a
colorful sash. Then, at last, we see HOLLYWOOD
MONTROSE, an exotically dressed, sunglass-
clad artiste TRILLING and WARBLING as he makes
his way down the runway. As he passes the
mannequins, each one suddenly … COMES TO LIFE.

The models follow him, strutting, bumping
and grinding in the unique Hollywood style.
Hollywood makes it halfway down the runway, then
stops. He turns, very patiently, to face his
Models - an exasperated preacher to his flock.

 HOLLYWOOD
 Ladies, remember your motivation!
 Once more, you are frozen. Like ice.
 Then, one magical day, you come to
 life! You can breathe! Your legs
 move! And I mean move.

He demonstrates, continuing down the runway in
a more outrageous strut.

 140

HOLLYWOOD
Are we communicating? Just because
Hauptmann-Koenig's drab, doesn't
mean we have to be. I'm going to
breathe some life into this
presentation.
Everyone, think Pizzazz!

Comedies generally require a peppy pace to fuel the laughs, so during
the editing process it became clear that some of the transitions and
extraneous dialogue were getting in the way of the spirited comedy. In
examining these two scenes, we realized that we could link the two
scenes by concentrating on Hollywood Montrose (who had become a
featured character after his successful debut in the first *Mannequin*,
1987).

Character names can be excellent transition points, and here it made
sense to springboard off the name Montrose as it occurs in Mr. James's
line, "We've just had an opening on Mr. Montrose's staff," and then cut
directly to Hollywood Montrose, leaving out everything after the line.
This allowed for the deletion of the walk and talk between Jason and
James, eliminating five paragraphs of dialogue as well as removing the
initial, slower introduction to Hollywood in the next scene and the two
paragraphs of needless dialogue before hitting the point of the scene:
"Just because Hauptmann-Koenig's drab, doesn't mean we have to be.
I'm going to breathe some life into this presentation."

Figure 13.3 Mannequin 2 – Hollywood Montrose directs.
Credit: 20ᵗʰ Century Fox.

If the script were transcribed as it was rewritten in the editing room, it would read something like this:

> After a few beats of silence, James slowly
> turns his head toward Jason.
>
> JAMES
> Now.
>
> JASON
> Uh … Jason Williamson. I was
> told to report to you. New trainee.
>
> JAMES
> Well it seems we've just had
> an opening on Mr. Montrose's staff.
>
> CUT TO:
>
> We see HOLLYWOOD MONTROSE, an exotically
> dressed, sunglass-clad artiste TRILLING
> and WARBLING as he makes his way down the
> runway.
>
> HOLLYWOOD
> Just because Hauptmann-Koenig's
> drab, doesn't mean we have to be.
> I'm going to breathe some life
> into this presentation.
> Everyone, think Pizzazz!

 For Editors: When looking for what to trim out of a film (and ultimately the story itself), editors look for redundancy or points where the story meanders, going off on tangents. Also hunt for scenes that contribute little to the story and would not be missed if they were removed.

The Power of the Dog, a story which has a fairly leisurely pace and relies a lot on character, needed something to break it up and differentiate the various moments. Ultimately, chapter breaks were introduced. These did not reflect the structure of the original novel or the script.

It was an invention of the editing room. But it made a big difference in the final cut. It allowed editor and director to cut to chapter breaks after key moments of information were dropped, creating a cliffhanger-like effect. That feeling was absent in earlier cuts that pressed onward without chapter breaks.

The chapter break transitions became significant structural elements in the film. Interestingly, the chapter numbers are displayed in Roman numerals, a nod to Phil's unexpectedly sophisticated background of having studied classics at Yale when he was younger. Also, a voiceover was added at the beginning: "I knew I had to save my mother," a line with multiple meanings that was not in the script but pays off at the end, bringing clarity to what might otherwise have been an equivocal ending. The line sets up the issue that Pete's mother, Rose, is going to need to be saved and it raises the question, from whom? And how will he accomplish that?

In summary, as a writer you should be mindful of how your story moves from one scene to another. In some cases, a line of dialogue can do the trick. In other cases, a question posed in one scene can become a springboard to another scene, such as in *Manchester by the Sea* (2016) where Lee Chandler (Casey Affleck) inquires about the doctor who was caring for his now deceased brother. This launches a flashback to the brother's hospital room where the doctor and Lee's family are in attendance.

Likewise, a declarative physical action can transport us. In *Totally Blonde*, Michael Bublé's character, Van, asks Liv, "You don't have a problem with tequila, do you?"

She replies, "No" and, as he steps away to retrieve a bottle, she adds in an aside, "It just makes me horny."

This cuts to a tighter shot of their two shot glasses hitting the table. Clearly time has passed, and they're now drunk and playing Truth or Dare.

In other cases, the writer can envision a camera move or an effect, such as a dissolve or wipe, that will transport a character across time and space. Consider the main character in *Pachinko*, whom we see alternating between her life as a young woman and as an elderly lady, often triggered by a camera move which was prefigured in the script.

14

FOLLOWING THE LINE

The chapter looks at how constructing too linear of a story can diminish the audience's involvement in the film, when to break continuity or incorporate non-linear elements. Ways to engage and engaging the audience by proposing challenges and puzzles.

Non-linear Trajectories

Many stories, and scripts, unfold in a linear manner. We go for a stroll with the story as if walking down a familiar street. There are turns and curves, but everything basically proceeds in a straightforward direction. Non-linear devices, such as flashbacks, are kept to a minimum.

At times, there is something comfortable about a story well told in linear fashion. This approach tends to reinforce Aristotle's early revelations about drama and storytelling in his *Poetics*. His conventions of time and space specified that stories should take place within limited temporal and geographic settings.

Novels, particularly modern novels, experiment with freeform narratives and elastic structures. Though James Joyce's revolutionary tome, *Ulysses*, still confined itself to a single day in a single place, Dublin, its free associational language, varied fonts, evocative imagery, and references spanning The Bible, *Hamlet*, and *The Odyssey* make *Ulysses* a unique and challenging read.

Film editors, who deal with time as it relates to rhythm and structure, often discover that a purely linear approach to story can lack satisfaction for the viewer. It can feel clichéd or anemic. Audiences want to be engaged. One aspect of engagement is offering viewers the chance to think, to decipher, to solve. In the same way that a scene told in a single take can lack the thrill that intercutting engenders, straightforward, uninterrupted stories can diminish energy. In chopping things up, the film editor invites the

 DOI: 10.4324/9781003161578-15

audience to participate at a higher level. Writers can benefit from this editing technique by finding appropriate places in their work to fracture the narrative.

An excellent example where the script's linearity was disrupted by director and editor to create a more discontinuous and compelling tale is seen in *The Limey* (1999). The clever script by Lem Dobbs begins with a rather novelistic backstory and fragmentary descriptions of Wilson (Terence Stamp), a grieving and dangerous father out to extract vengeance for the death of his only daughter, Jennifer (Melissa George). Dobbs has emphasized his interest in highlighting scenes that included more detailed backstory, including references to Wilson's boss back in London.

```
EXT. ARRIVALS TERMINAL. L.A. AIRPORT.
AFTERNOON.

WILSON steps out into the late sunlight and
the heat of the day. A slow-motion moment
while he gets acclimatized. He wouldn't
have ever felt quite this kind
of heat before. After such a rigorously
air-conditioned interior. Or seen cops
wearing guns on their belts. Or black cops,
for that matter, with guns on their belts.
Or seen people as fat as Americans on their
home turf. Things someone from England
notices immediately, whether consciously at
first or not.

                                        CUT.

EXT. MOTEL. EVENING.

Wilson's not here for comfort. Shown to a
shitty room, round the corner of a typical
2nd-level outside walkway. Airport close
by.

INT. MOTEL ROOM. EVENING.

He draws a curtain open across a window in
one strong easy glide. His moves are neat.
His expressions just as economical, not
giving much away. Outside the planes are
practically on top of us. The sunset colors
strange and chemical.
```

He's only got one light bag. Unzips,
unpacks a few things. Change of clothes,
a travel kit, and some familiar items
(shaving foam/toothpaste/deodorant} bearing
unfamiliar British brand names.

Goes into the bathroom. Turns on the shower
in there.

Comes back to sit on the bed. Takes an
envelope out of his jacket.

ENVELOPE

Turns it over to see the return address on
the back.

CUT.

INT. TAXI. NIGHT.

Wilson in the back. Stares at the
impenetrable name on the driver's posted
ID. Glances at the driver.

DRIVER glances back at his quiet passenger in
the rearview mirror.

CUT.

EXT. SMALL HOUSE. NIGHT.

Wilson walks up a cracked little path to
the front door. Lower middle-class street.
Two cars in the driveway, one behind the
other. Lights on inside the house - as he
rings the bell.

ED RAMA

Answers it. Hispanic. Late 30's. Chairman
Mao on his T-shirt notwithstanding, an
easygoing sort of fellow. Not looking for
any trouble - anymore. But once did, and
able to handle himself if any shows up.
Which it has.

146

```
                    WILSON
          Edward Rama?

                     ED
          Eduardo.
               (rolling the R)
          Rama.

                    WILSON
          You're home, then.

     He turns, waves away the taxi he's kept
     waiting. While Eduardo Rama waits for an
     introduction.

                    WILSON
          My name's Wilson.

     Accent speaks for itself. Hard, working-class.

                     ED
          Wilson?

     Knows the name. But just now it's unexpected.
     He's holding a hot TV dinner, hand protected by
     a dish towel.

                    WILSON
          You wrote to me about my
          daughter.
```

The screenplay's distinctly literary flavor is peppered with occasional cinematic leaps in the form of brief flashbacks introduced here and there to break up the pages of frontloaded dialogue. Other than that, the story proceeds in a linear fashion.

The editor, Sarah Flack, ACE, and the director, Steven Soderbergh, took it to a whole different level. Soderbergh, who has a keen understanding of the genre, pointed out that he "didn't want to stray far from the spine of the film, which was [Wilson] and his daughter" and he found that "the script, filmed in a straightforward manner, was too conventional."[1]

So, director and editor broke the mold by deconstructing the script's linear narrative into a jagged array of images and dialogue pieced together from various parts of the film. Doing this created an engaging and well-paced story, consequently leaving out large swaths of dialogue, planning, and backstory.

Figure 14.1 The Limey – Wilson in search of his daughter's killer.
Credit: Artisan Entertainment.

This approach was partially influenced by the director's exposure to the works of the French New Wave, such as the films by Alain Resnais (*Hiroshima Mon Amour*) and Jean-Luc Godard (*Breathless*).

 For Editors: The poetic, less linear, discontinuous films of the French New Wave had an early and ongoing influence on American cinema. Films that Hollywood studios would never have greenlighted ultimately ended up influencing Hollywood film-making, particularly in the realm of editing. Today, there is hardly a film that does not employ Godard's jump cuts to energize the story and move the plot along. And Alain Resnais's weaving of images has found its way into many American films, including Soderbergh's *Out of Sight* (1998), starring George Clooney.

In this final rewrite of the film, moments glimpsed in the opening sequence are only partially realized. The full nature of the images or dialogue is revealed later or at the very end, including close-ups of Wilson on the plane or Wilson's voice over black, imploring, "Tell me ... tell me ... tell me about Jenny." Toward the end of the film, we discover that these early moments are actually culled from the end of his journey, as he settles into his airplane seat on his way back to England, or when he confronts the antagonist, Terry Valentine (Peter Fonda), respectively.

The final iteration of *The Limey* begins with the arrival of Wilson at Los Angeles International Airport (LAX). A rack focus reveals him in close-up. Next, we're with him in a taxi. Then we follow Wilson as he enters a cheap hotel room.

Wilson pulls out an envelope containing a news clipping: *Woman Dies on Mulholland*.

He turns over the envelope to reveal the sender and his return address: Ed Roel (Luiz Guzman) -- known as Edward Rama in the original script. This image jumps to:

Wilson in an airplane.
Wilson in a car, his hand lifting up a black and white photo of his daughter Jenny.
A close-up (CU) of Wilson in the hotel room.
A home movie of his young daughter on a beach and staring into the camera.
Wilson's CU in the hotel room again. (The cut connects the two images.) Then his CU on the plane, contemplative.

Daughter Jenny on the beach again. Followed by a grainy shot of Jenny, a bit older and framed by a door. Wilson's humming plays over this section. This cuts to:

CU of Wilson in the hotel room with a cigarette, thinking. Then the following cuts:

Jenny in the passenger side of a car while Ed drives.

The black and white portrait of Jenny, older. The camera tilts up to reveal Wilson, studying it from the passenger's seat.

Back at the hotel, Wilson in medium close-up (MCU). Then a wider shot of Wilson smoking beside the hotel bed.

A night driving shot of Wilson in the back of a cab.

A wide shot as a car ascends the hill toward camera. The camera pans to show Wilson exiting from the taxi in a residential area.

A medium close-up (MCU) of Ed Roel as he opens his front door.

CU of Wilson. His first words on camera: "Edward Roel."

MCU of Ed Roel: "Eduardo."

CU Wilson: "You're home, then." He turns, waves away the taxi, then turns back and announces, "My name's Wilson."

CU Ed: "Wilson?"

CU Wilson: "You wrote me about my daughter."

Both approaches take us to the same point (i.e., "You wrote me about my daughter") but in quite different ways, one more compelling than the other. The fragmented editing approach continues throughout much of the film.

Later in the script, Wilson and Ed discuss getting Wilson a gun so he can pursue whomever killed his daughter.

 WILSON
 I'll be needing a
 shooter.

Makes his fingers like a gun. And a clicking
sound.

 ED
 (comes quickly over)
 You're kiddin' me, right?

 WILSON
 What do I do, then,
 look in the bleedin'
 Yellow Pages?

 ED
 (an urgent whisper)

These are not guys you can
just go run a number on, man.

 WILSON
 (looking around)
 Thought perhaps there'd
 be dispensing machines,
 you know. Bung in your
 coins, come out with a
 .44 Magnum, fully-loaded.

Ed throws up his hands, walks back to his
driver's side door.

 ED
 Are you a resident
 of California? You gonna fill
 out forms, man? Do the
 background check? Go through
 a three-day waiting period?

 WILSON
 Sod that. Gotta get back before
 my probation officer wonders
 where I've shived off to.

 ED
 Probation? Man, you
 crazy. They shouldn't've
 let you outta your country,
 much less prison.

 WILSON
 Traveling on a dodgy
 passport, n' all.

Walks round to come face to face with Ed once
more.

 WILSON
 Which is why I thought, save some
 time, get what I need under the
 table, like.

 ED
 (as if resigned and mulling

```
                      the problem over)
                    Under the table?
```

From here, in the script, the scene cuts to a gun show with hundreds of tables displaying endless firearms, with several pages of dialogue between Wilson, a gun dealer, and Ed. In the final cut of the film, however, the gun issue is dispatched in a couple of quick cuts as Wilson acquires two guns, literally under the table, on a school playground, an irony that the director added.

Cut to a gun being passed under a table.

Back to his CU, then under the table as another gun is passed.

Medium shot of Ed in sunglasses outdoors with Wilson's head framing the left side of the frame.

Wilson pacing his hotel room.

CU of Wilson in the hotel room, pensive. He reaches down. A match cut to his hand reaching under the table, handing over a wad of bills. Another hand takes the money.

In a JUMP CUT, the hand passes back a plastic bag full of bullets.

CU Wilson in the hotel room, thinking.

CU Wilson outdoors, his eyes shifting back and forth.

Medium wide shot – two boys sitting on the opposite side of the table, standing up. In a continuous match cut they leave in a WIDE SHOT over Wilson's shoulder.

It's interesting to note the accomplishment of showing Wilson's character thinking. Something that is often a springboard to flashbacks, but here is used at times as simply a contemplative moment.

The Limey, though well written, was full of long passages of dialogue and additional scenes that are more captivating on the page than off. This excessive exposition became apparent in the dailies and led editor and director to find ways of propelling the story forward.

Figure 14.2 Top Gun – The volleyball game.
Credit: Paramount Pictures.

Recently, upon the release of *Top Gun: Maverick* (2022), the editors of the first *Top Gun* (1986), Chris Lebenzon, ACE, and Billy Weber, looked back at how they fractured a once linear scene from the original screenplay. According to Lebenzon, the volleyball scene with Maverick (Tom Cruise) was thoroughly scripted as a real game. "They kept score and everything," he pointed out. But the director, Tony Scott, who began his career in commercials and music videos, "shot it like a commercial, and they were angry." Weber echoed this, adding,

> The studio was so pissed off. The head of production, Charlie McGuire, he said, "I'm gonna fire him" … because he spent a whole day shooting this scene. … And then of course it turns out to be one of the most famous scenes in a movie.[2]

One might ask, could a writer have conceived of such wild juxtapositions at the writing stage? Perhaps not in the exact manner as these examples, but, in adopting the editor's approach to rhythm and momentum, the writer can move into a realm where long conversations give way to imagery and action and where straight lines become mosaics. As we have seen, these are compelling options in telling a screen story.

 For the Writer: Exposition in itself is not harmful. In many cases it is essential to understanding the salient points that allow the story to progress. But it carries with it the danger of keeping the audience at arm's length. Instead of enticing them into the story and inviting them to engage, it ignores their capacity to empathize, to decipher, to question – all capacities that pull us into a story and, for that matter, into life itself.

Notes

1 Soderbergh, Steven. *The Limey*. Director's DVD commentary. Artisan. 1999. Also see Jamie Kirkpatrick's webinar, "The Third Rewrite: The Editor as Storyteller." Motion Picture Editors Guild. Nov. 12, 2022.
2 Giardina, Carolyn, and Aaron Couch. "Behind the Screen podcast." Hollywoodreporter.com. June 4, 2022.

15

FORMULA BUT NOT FORMULAIC

This chapter considers genre as another significant aspect of audience involvement. Genre creates expectations in an audience. This chapter explores: how to fulfill genre requirements; genre and myth structure as the formula for successful stories; avoiding the formulaic aspect of formula; and how a writer and, eventually, an editor bring out the unique elements of a story while disguising the machinery operating beneath.

Genre

The *Oxford English Dictionary* calls genre "a category of artistic composition ... characterized by similarities in form, style or subject matter."[1] Genre comes in many flavors and colors, from comedy to horror to action to thrillers. In films, genre relates to emotion, conjuring anticipation of what the audience will feel in the course of the movie. To evoke feeling is the primary function of film. At its best, that feeling will also bring understanding and insight.

Plot relates to genre. Genre is an organizing force that unites the story's premise and the characters' actions. It triggers the beginning and resolves the ending. Genre is part of the question, "What is the story about?" It also sets up the emotional landscape of the story. Will we laugh, cry, or scream?

Beginning filmmakers sometimes dismiss genre in an attempt to defy its traditional origins. And genre, in a sense, is nothing if not conventional. Each genre has its accompanying tropes. In the strict sense, genre posits a variety of conventions that ask us to adhere to time-honored storytelling values. Along with that are the accompanying expectations that those conventions bring. Put simply, an audience for a comedy expects to laugh;

DOI: 10.4324/9781003161578-16

an audience for a horror film expects to be frightened. Genre serves to classify films and even delineate a path for the marketing of the film. The first question distributors ask is, "What kind of film is it?" It's a comedy or a horror film or a fantasy or a sci-fi.

Yet, even with all the conventions, genre mutates over time. As societal expectations change, so do aspects of genre. Whether you are a writer or an editor, it is essential to understand the elements that make genre work.

Early in the writing process, writers need to discover what genre they are working in and build toward that. While most writing guides discuss structure, dialogue, and setting, many neglect the essential element of genre. Often, the editor becomes the final arbitrator and defender of this element. The action film that is overloaded with dialogue, the comedy that is weighted down by complex plotting, or the thriller that tells rather than shows have all ended up on the editor's bench to be retooled.

If one looks at genre in its most basic and primordial form, one sees that it is the reflection of a myth cycle with its accompanying iconography. Myths, those recurring tales carried through time that have archetypal resonance with all humanity, are the basis for drama and, consequently, for genre.

Genre determines character. Superhuman characters don't appear in thrillers because the basic character in a thriller is an average citizen caught in something beyond their control, like Roger Thornhill, Cary Grant's character in *North by Northwest* (1959), who is swept into a world of international espionage merely because of mistaken identity.

The thriller is a victim myth that transforms based on knowledge – the realization that the safe person is really the most dangerous one. If the protagonist were Batman or James Bond, the story and outcome would be entirely different. In this way, the character's dramatic arc is altered depending on the genre. Characters in thrillers find themselves thrust into perilous and even terrifying situations, only to experience an epiphany at the end when they realize their power to save themselves. Comedic characters, on the other hand, find liberation and a sense of freedom through good-humored confrontation with societal mores and by challenging the norm.

The film *Fatal Attraction* (1987) is a highly engaging and resonant thriller that lost its way by the end of the script's third act. Here, the choice between diegetic and non-diegetic – show rather than tell – became obvious. Salvaged during the post production process, the failing film went on to become a major hit. It was written by James Dearden, directed by Adrian Lyne, and edited by Michael Kahn, ACE.

In the original script, a married man, Dan Gallagher (Michael Douglas) has a brief tryst with a young book editor, Alexandra "Alex" Forrest (Glenn Close), who obsessively stalks him after he tries to break off the relationship. Eventually, Alex becomes violent, killing the family's pet rabbit and kidnapping their daughter. After the child is returned, Dan breaks into Alex's apartment and attacks her, choking her. When she grabs a kitchen knife to fight him off, Dan manages to wrestle the knife away from her and leave. He calls the police and reports the kidnapping. Here's how the original script ended.

```
EXT. COUNTRY HOUSE - FRONT YARD - DAY

The three men are walking over. Dan approaches
confidently.

                    DAN
               Afternoon, Lieutenant.
               Did you get her?

                    LIEUTENANT
                    (nods)
               Mr. Gallagher, this is
               Lieutenant O'Rourke, Detective
               Fuselli. New York homicide.
               They'd like to ask you a
               few questions.

                    DAN
               Sure.

He suddenly registers what the Lieutenant just
said.

                    DAN
                    (continuing)
               Excuse me … Did you say homicide?

                    O'ROURKE
               That's right.

                    DAN
               Why? What's this got to do
               with -? What about Alex Forrest?
               Did you get her?
```

> O'ROURKE
> No, we haven't, as a matter
> of fact. You saw her last night?

> DAN
> Yes … I already told the
> Lieutenant here. Why -
> what's she saying?

> O'ROURKE
> (drily)
> She's not saying very much, Mr.
> Gallagher.

Fuselli snickers unpleasantly.

> O'ROURKE
> (continuing flatly)
> She's dead.

Dan is completely stunned. They all stop.

> DAN
> She what? She's dead???

> FUSELLI
> That's right.

O'Rourke stares back at him, saying nothing.

> DAN
> How?? How did she …
> (suddenly awed)
> You think I did it …? Oh, Jesus …
> (You think I killed her) … Oh, Jesus.

At that point, Dan is arrested and taken away by the police. His wife, Beth (Anne Archer), panics and hurries inside the house to call their attorney. As she's looking for the phone number, she spots a cassette tape labelled PLAY ME. She plays the tape and listens as Alex confesses her obsession with Dan and promises to kill herself: "When you push me away you give me no other choice. I'll cut deeper next time. I'll kill myself!" Dan is acquitted.

On paper, the dialogue is clever and engaging, the tension of the arrest palpable. But the script missed the most important final beat. When the film was test screened, audiences hated it. They felt cheated. Sewing up the loose ends of an otherwise powerful thriller in a recorded message felt incredibly diminuendo.

The star, Michael Douglas, has said that in a test screening, when Alex Forrest took her own life,

> the audience went, "No man, no, you gotta kill her." ... As bad as I had been ... once she went after the family all bets were off ... [The audience] wanted us to do her in. ... That was the audience's catharsis, isn't to allow her to do herself in.[2]

At this point, the filmmakers realized that, to remain true to the genre, Dan and Alex had to confront each other head on and, as in most thrillers, one of them had to die. Rewriting, reshooting, and re-editing the film's ending led to a spectacular success.

Figure 15.1 Fatal Attraction – The cassette recording.
Credit: Paramount Pictures.

Writers can take a lesson from this. It's not enough to establish strong characters, a riveting plot, and clever dialogue. The story has to work within the bounds of the genre.

Ritual Objects and Story

In my advanced editing classes I often ask students to bring in an object to talk about. Not just any object, but one that means something to them.

Many speak with great candor when revealing objects that have reso-
nance for them. During the Covid-19 pandemic, when everyone was on
Zoom, students were even more profound in their sharing, whether from
the extra time they had to think about it or the more personal nature of
being online or the shared humanity of the pandemic experience.

In this exercise, the more guarded students might bring in a ping-pong
ball and talk about their skills at the game. Others spoke more openly,
showing a ring that belonged to a great aunt who had died, the linen trim
that was all that remained of a childhood blanket that still comforted
them, and so on. As they spoke about their particular objects, we could
see that the item, which might be tattered, worn, or tarnished, had been
imbued with deep meaning.

Genres carry their own object identification that promotes their themes
and meaning. Like Tom Cruise's line in *Jerry Maguire*, "Show me the
money," the writer and editor should heed the call to "show me the
object." Consider this: what objects are associated with your favorite
genres? The romantic comedy, for instance, often ends with a wedding or
the promise of a wedding, carrying with it the object of a wedding ring.

The first wedding scene in *Four Weddings and a Funeral* (1994) is full
of comedic tension surrounding the best man's last-minute discovery that
he (Hugh Grant) has lost the wedding ring. His subsequent dash to gather
the object before the vows end leads to a replacement ring that is surrep-
titiously solicited from the audience and placed on the bride's finger. It is
ugly as hell. And funny. And the significance of the object is without
question.

Figure 15.2 Four Weddings and a Funeral – The ring.
Credit: Metro Goldwyn Mayer/Gramercy Pictures.

In the mystery film *Where the Crawdads Sing* (2022), a shell necklace appears again and again throughout the story and, in the end, supplies a powerful reveal for the film's conclusion.

What about horror? One of the strongest, most persistent myths of the horror genre is the vampire. Most people can easily identify the iconography of that genre, including wooden stakes, garlic, crosses, mirrors, smoke, bite marks, and coffins.

Also, consider two genres that share similar structures in the hero myth, though at different ends of modern history. One – science fiction – looks forward into the future with lasers, space ships, and distant planets, while the other – Westerns – looks back to technologically simpler times with six shooters, horses, and the rural frontier. These hot objects, or synecdoches, are imbued with great meaning that resonates throughout the story.

Just as it's important to reinforce the presence of characters in a scene, even those who aren't speaking, filmmakers discover the necessity to keep alive the objects that reinforce the genre and the message. Many a time I've asked for or directed pick-up shots to gather inserts of those important objects. Though essential, the object might not be given its proper due in the script and therefore is passed over in production. Even if these items were incorporated, they were sometimes relegated to wide shots or alluded to in dialogue, but never brought to the foreground where the audience can see and feel the significance of these guiding icons.

Formula

In terms of genre, it's important to distinguish genre formula from formulaic writing. Genre gives writers a guide for building powerful stories that fulfill the needs of an audience. Consequently, genre creates particular expectations in the audience. This sounds simple enough, almost obvious. Yet the dynamics of creating scenes that satisfy these expectations can be elusive. When genre issues aren't fully dealt with at the script stage, they emerge again during the post production stage.

The classic Christmas film *Prancer* (1989), written by Greg Taylor (*Jumanji*) and directed by John Hancock (*Bang the Drum Slowly*), is another example of genre's influence. As a family film, which is also a Christmas movie, *Prancer* needed to fulfill several expectations. First, as a family film, there would need to be some kind of reconciliation at the end, a sense of the strength and the enduring quality of family. Second, as a Christmas movie, it needed to promise some sort of magic, such as is seen in *It's a Wonderful Life* (1946), *A Miracle on 34th Street* (1947, 1994), or *Elf* (2003).

In *Prancer*'s case, the question of faith played a major issue. This is posed by the poem that farmer John Riggs (Sam Elliott) reads to his daughter Jesse (Rebecca Harrel): "is there really a Santa Claus?"

The poem's reply is: "Yes ..." In the case of *Prancer*, this tied into the question of whether the wounded reindeer that Jesse finds and nurses back to health is really one of Santa's. Is it Prancer, as Jessie suspects?

The original ending as written left this open-ended. Prancer, fully recovered from a gunshot wound, is driven out to the woods in the family's pickup truck by farmer John, accompanied by his daughter Jessie. The final farewell scene is played between Jessie and Prancer while Jessie's father looks on from the distance.

```
        She looks at Prancer for a long moment. We
        finally see the resolve in her eyes.

        She grabs the latch quickly, closes her eyes
        and snaps it back. The door flies open and
        Prancer LEAPS out.

        He turns and runs gracefully into the pines
        toward Antler Ridge. He looks beautiful.

                        JESSIE
                Prancer!

        Jessie runs after him.

        ANGLE - JOHN

        His instinct is to run to her. Stop her. But he
        holds back.

        EXT. FOREST ANTLER RIDGE - NIGHT - PRANCER

        Runs down a long corridor of pines, jumping
        fallen branches, bells tinkling.

        JESSIE

        moves after him as fast as she can.

        HER MOVING POV OF PRANCER

        He's moving away from us. We can't catch him.
        He's starting to fade from view. The snow has
        stopped.
```

JESSIE

Running, trying to see him one last time.

PRANCER

Disappearing into the light at the end of the corridor of pines. He's gone now. His bells are still audible, growing fainter. Now they're gone.

EXT. CLIFF ANTLER RIDGE (STARVED ROCK) - NIGHT - JESSIE

breaks through the trees into a clearing. Move with her to reveal that the ground drops off here at a cliff. Just a few lights from the town are visible from this angle. We're at Antler Ridge.

Jessie stops, looking around. Prancer's nowhere in sight. She looks to the left, the right. Where could he have gone? His bell collar is lying in the snow. She picks it up. John joins her, points -

THEIR POV - THE HOOFPRINTS

lead over the edge.

JESSIE

walks forward, looks out over the cliff -

POV

No sign below of the deer.

MATTE SHOT ANGLER RIDGE - NIGHT

As John joins her we look over them, out over the cliff and into the valley with the little

162

> town of Three Oaks. How could he have gone out
> <u>there</u>?
>
> We'll never know. Believe what you want to
> believe. Jessie's made her choice.

But as an audience we want to know. We've waited nearly two hours to find the answer, yet "we'll never know." The equivocal ending in the script led to a simple rewrite in the editing room. The answer to the question that was posed at the beginning – is this reindeer really one of Santa's? – needed to be made clear.

By introducing some subliminal dissolves that effectively made Prancer seem to disappear in the last moments of his run – if you blinked, you missed it – and adding the sound of distant bells to the soundtrack, superimposing a glow across Jessie's face as she looks skyward, and finally presenting the cathartic reveal of a distant Prancer streaking across the night sky and rejoining Santa's sleigh as it crosses the full moon, we created a satisfying ending that brought the film in line with its genre.

Figure 15.3 Prancer – Bidding farewell to Prancer.
Credit: Orion Pictures/MGM.

Sometimes it's a challenge to find the correct approach. Especially these days when mixed genres abound. During the editing of *Don't Look Up* (2022), starring Leonardo DiCaprio and Jennifer Lawrence, director Adam McKay and editor Hank Corwin, ACE, had to establish the true genres and, consequently, the true emotions that the film would seek to

engender in its audience. On the surface, the subject matter is deadly serious and harrowing – the end of the world by a massive comet strike. But it is also a comedy, a cinematic satire in the manner of *Dr. Strangelove or: How I Learned to Stop Worrying and Love the Bomb* (1964).

Kubrick's film, *Dr. Strangelove*, was originally based on a serious novel, *Red Alert* by Peter George, about nuclear annihilation. It was a warning to the world about the consequences of nuclear mismanagement and the foolhardy mission of putting trust in the atom bomb and those who maintain it. The story's consequences were so horrific and so close to reality that the filmmakers found themselves making off-color jokes as they attempted to construct a serious dramatic script. Ultimately, Kubrick's sense of humor won out, and the characters evolved into buffoons and madmen on a foolhardy mission in a dark, satirical comedy.

Similarly, *Don't Look Up* is part comedy, part tragedy. Editor Corwin explained, "I like to think in terms of collage as opposed to montage – especially in this film. I don't want to make scenes overly polemical. I don't want to make scenes overly political. I think the politics that are really important are the politics of emotion and of will." He and the director worked hard to discover the correct tone of the film.

> It was a moving target. Initially, I saw this film as a great sadness, a real tragedy. I didn't see this as a comedy. ... If I had done that, the film would have been very earnest and I suspect it wouldn't have been successful. Adam kept wanting to balance the tone. We had to have levity. It's a comedy, but everything must be plausible. He had me constantly pulling back the comedy. I don't come from a funny world like Adam does. ... I had to make the scenarios more serious and somewhat plausible, even if they were funny.[3]

This reinforces the need to discover the genre and determine the tone that the writer wishes to affect. As in cases such as *Don't Look Up*, comedies deliver their messages through laughs and not through heavy polemics, though a film like *Triangle of Sadness* (2022), with its theme of status and societal inequality framed by crazed political discussions between the ship's alcoholic captain (Woody Harrelson) and a fertilizer tycoon (Zlatko Buric), bridges the two.

Figure 15.4 Don't Look Up. The scientists confront the inevitable.
Credit: Netflix.

In *The Convent*, another mixed genre film, director Mike Mendez's passion for horror, including graphic gore, at times vied with the comedic aspect of the film. The opening scene of violence in the inner sanctum of the convent, involving a baseball bat and shotgun, were originally shot in slow motion which, as Sam Peckinpah (*The Wild Bunch*) discovered years ago, makes violence appear all the more horrific. In our case, it became clear that going in the opposite direction, that is, speeding up the action, would give the events a sort of cartoon violence aspect with a herky-jerky, Keystone cop-like action. This carried over into the later zombie scenes where the once slow, dragging zombies – zombies can wreak havoc on a film's pacing – took on a frantic, crazed cadence. Aside from helping propagate the comedy, it also picked up the pace and added excitement to this horror comedy.

Documentary is another genre that poses challenges. Some documentaries are constructed from random footage collected over the course of months or years. It becomes the editor's job to discover characters and story while structuring, a clear throughline. Other documentaries benefit from copious research which is incorporated into interviews, voiceovers, and recreations. Here, too, the editor's choices are instructive to the writer.

On a show for National Geographic, I found that the initial script with which we were presented and which was used to initiate the interviews and B-roll, morphed into a new creature with each iteration of the cut. As the editing progressed, the newest versions were handed back to the writers so they could fill in the gaps or follow the new line of thought. The original story was reworked in this way, many times. In the end, the final script had little resemblance to the first draft. In that sense, it can be reassuring to writers to know that they shouldn't expect the early drafts of

their work to resemble the well-wrought professionally edited final film. But understanding the process will take them a long way toward getting through the work successfully.

Notes

1 *Oxford English Dictionary*. Oxford University Press. 1971.
2 Sirius XM. "Michael Douglas Remembers the Alternate Ending of Fatal Attraction." December 4, 2018.
3 Feld, Rob. "Hank Corwin Talks Editing and Collaboration in 'Don't Look Up.'" *CineMontage*, Journal of the Motion Picture Editors Guild. December 20, 2021.

16

THE END IS THE BEGINNING

This chapter looks at the importance of endings, one of the most frequently dealt with issues during the final editing stage. Where do endings go wrong? What is the purpose of an ending? How do writers and editors discover the proper ending? Is the beginning or the ending more important?

Endings are hard, and "parting is such sweet sorrow,"[1] as Shakespeare observed. Endings are the final impression that the audience takes away from a film or television show. In TV, some seasons wrap up dramatically, while introducing a complication that will carry over into the next season, such as the second season of *Sanditon* (2019) with Rosie Graham, Rose Williams and Crystal Clarke, or the beautifully crafted wrap-up to the first season of *Peaky Blinders* (2013). One of the most famous endings was the season conclusion of the show *Dallas* (1978–1991) where the lead character, J.R. Ewing (Larry Hagman), was shot. The tagline for the next season became "Who shot J.R.?"

To better understand the ending, look to the beginning.

In crafting a screenplay, the approach to the beginning is paramount. The reader's attention is primed in those first pages. They want to know several primary considerations – what is this story about, who is this story about, and why should I care?

A magnetic character whose altruistic motives are misunderstood could be a good start. Or a troubled and conflicted character with a good heart. Or a myriad of other traits with which the reader can identify. It is also essential that our character have a big problem, something nearly insurmountable that needs to be solved. It could involve saving the world or just saving a friendship, a marriage, or a community. It should be an issue that resonates with the reader.

DOI: 10.4324/9781003161578-17

Figure 16.1 Sanditon - Women of Sanditon.

Credit: *PBS.*

As mentioned earlier, some screenplays begin with an emergency. Desperate events have a way of immediately catching a reader's attention and holding it.

Some screenplays start with a mystery, such as the phenomenon of strange lights and unexpectedly animated toys in *Close Encounters of the Third Kind* (1977).

These kinds of openings can launch a script that is hard to put down. After the premise has been stated and the problem made clear, it's up to the writer to hold our attention through the long journey that is the middle and then wrap it up with a satisfactory ending.

Since screenplays are intended to be read, it is essential that those first pages reach the reader's emotional and intellectual core. Books, screenplays, and plays are often sold based on a gripping opening with well-crafted characters.

This fact might lead one to believe that the beginning of a film is the most important part. But consider this: if the film is successful and, through word of mouth, social media, online reviews, and advertisements, you are driven to buy a ticket or stream it, what becomes the most important aspect? Certainly, everything that follows is important. You might be willing to wade through an essential, yet less engaging, set-up at the beginning.

The set-up will prepare you for later plot twists and character discoveries. What you don't want is to sit with a film for 45, 90, or 120 minutes only to see it sputter out at the end. How unsatisfying would that be? And the chance that you'll recommend the film to your friends or write a favorable review or click five stars instead of two will depend on how the film ends. Will the problem that was established in the beginning be resolved in the finale?

Endings are one of the most frequently dealt with issues during the final editing stage. Endings are hard. There are numerous tales of films that struggled to find the right conclusion, including one of the greatest films of all time, *Casablanca*. The writers, Julius and Philip Epstein along with Howard E. Koch, were still crafting the ending while the film was in production. This despite all the advice of writing gurus to know your ending before you embark on the beginning. Yet what an amazing ending. The final farewell between Rick and Ilsa is one of the most enduring scenes in American cinema. But it was hard fought.

Where to Begin

Within the first ten pages, we meet the story's main characters. The first moments can be pleasant and attractive, but quickly a disturbance occurs which pulls us out of our comfort zone. Like the opening of the Western *Silverado* (1985). It begins with the gentle crackling of a wood-burning stove inside a dark shack, moments before bullets explode through the walls, disrupting the peace and awakening a sleeping Scott Glenn who grabs his Winchester and returns fire, killing three of his assailants.

Or the interior of another cabin in *The Shawshank Redemption*, when the door suddenly bursts open, and a man and woman in the throes of passion charge inside and begin making love.

Or the silent universe, after the opening title crawl, at the beginning of *Star Wars*, just before a huge space craft rockets overhead.

All these are gripping moments that immediately capture our attention. And each leads to an ensuing crisis. A shoot out that launches our hero on his way to Silverado, a sex scene turned into a homicide, and a battle by rebel forces.

How you begin will affect the end. So, consider the beginning carefully. And, be sure to follow it through to the end, rather than wandering off onto another path.

But how do you craft an effective beginning? The great film *The Shawshank Redemption* had an engaging and well-structured opening. In it, the opening sex scene turns out to be an extramarital affair that sparks the jealousy and revenge of a husband, Andy (Tim Robbins), who has refused to grant a divorce. Drunk and armed with a .38 he approaches the house in a jealous rage. When the couple is found murdered the next day, Andy is identified as the killer and sent to a high-security prison.

In the original shooting script, the cabin scene is followed by a courtroom scene where Andy is found guilty and sentenced to two life sentences. The courtroom and jury room scenes are interspersed with the film's opening credits. On paper it read great. The lovers wrestling in an impassioned embrace, the jealous husband approaching the cabin, the revolver spilling bullets as he staggers toward the sounds of lovemaking, the arguments and cross examinations in the courtroom, and the final sentencing along with

the introduction of a new character, a prisoner named Red (Morgan Freeman), who has been denied parole on multiple occasions.

All these scenes move along in an engaging, and highly linear, fashion. By the end of the first seven pages, the main protagonists, Andy and Red, have been introduced, and their conflicts have become clear. Red has been denied parole again after 20 years, and Andy is about to serve two lifetimes for a crime he may not have committed. Both have serious problems.

But what worked in the script did not work in the editing room. According to the writer–director Frank Darabont,

> The screenplay's approach of playing as separate blocks of consecutive narrative proved somewhat protracted and boring when viewed on film. Additionally, the written technique of dividing up Scenes 5 through 8 (the trial) with "fade to blacks" to accommodate the titles seemed like a good idea at the time, but also served to needlessly protract the sequence – indeed, it managed to stop the narrative flow dead in its tracks. ...
>
> The solution I came up with in the cutting room, heartily embraced by my editor and producer, was to reconceptualize the two separate blocks of narrative into a single title sequence focusing on the trial (really the point of the whole thing), with the footage of the lovers used in a more sparing "flashback" manner.[2]

In doing this, director and editor improved the pacing by trimming down the long lovemaking and cabin scenes, which accounted for two full script pages at the beginning, and getting to the trial quicker, where extraneous lines of dialogue were removed. Then, the titles were superimposed over the scenes rather than interrupting the flow by going to black each time. From a series of separate scenes, the material merged into a powerful and well-paced opening title sequence.

Figure 16.2 Silverado – Inside the cabin.

Credit: Columbia Pictures Industries, Inc.

The End

What is the purpose of an ending? How does the writer discover the proper ending? Is the beginning or the ending more important? Where do endings go wrong?

Hollywood was notorious for supplying unrelenting happy endings for its audiences. Without a happy ending, a script generally would not be green lit, and a film without a pleasing ending was considered doomed to failure. The peddling of happy endings was interrupted in the late sixties and early seventies when a desire for less fantasy and more reality set in, influenced by a generation coming of age during times of war and rebellion. Today, while most films still supply an upbeat and hopeful conclusion, some are less optimistic in considering the consequences of real life, such as *Tár* (2022) or *All Quiet on the Western Front* (2022).

It is not merely the happy ending that today's more sophisticated audiences require. They have seen films of strife, inequality, violence, and abuse. It is the satisfying ending that produces, perhaps, the greatest effect. To create the best ending, the writer, director, and editor need to understand the dilemma that was posited at the beginning of the film and determine a satisfying resolution at the end. When the central conflict becomes diluted or diverges in the course of the film, the filmmaker needs to guide it back to the throughline and, in following that trail, discover an ending that answers the questions, fulfills the emotional arc, and solves the riddle of the opening.

Much of this is genre-specific.

In traditional Westerns, the lone hero to whom many have become attached, who has proven worthy and even gained the love of others, rides off into the sunset at the end. This exit, seen in *Shane* (1953) starring Alan Ladd, *The Searchers* (1956), *The Magnificent Seven* (1960), and a myriad of others, while bittersweet, reinforces the heroism and individuality of the main character.

In romantic comedies, however, it must generally proceed the other way around. The lovers, after all the misunderstandings and fights, the disapprovals of friends and family, eventually acknowledge their love and, most likely, marry.

Editors frequently encounter these issues. In my own experience, it seems that in nearly half the films I've edited we had to re-evaluate the ending as written. Extra beats were removed, promises were kept, and heroes prevailed. Know your audience. Be aware of their expectations. Fulfill those expectations in a unique way. For any film, there was only one proper ending, and that's the one that finally made it into the theater.

Figure 16.3 Shane – "Shane, come back."
Credit: Paramount Pictures.

How do editors evaluate endings? What measure can be applied to determine the correctness of an ending? To discover the ending, look to the beginning. Has the film answered the questions that were set up in the beginning? Billy Wilder (*Some Like It Hot, Sunset Boulevard, Double Indemnity*) said you can't get a third act if you don't have a first act.

Viewed another way, narrative films are about an existential question, whether it is who will you marry, what is the meaning of life, what is death, how do you find true happiness, what is the right livelihood, and so on. Like all good inquiries, the answer is imbedded in the question and how the question is posed. If you ask the wrong question, you get the wrong answer. In film, the beginning, which posits the question, must be related to the ending that answers it. The resolution. Along the way, we experience the struggles in determining the final answer, the conclusion.

Your main character's want and need play into this. Perhaps the answer will reveal that the initial need wasn't a need at all but a want. In some cases, your hero or heroine will achieve what they want, what they've

worked and fought for, only to discover that it's not truly what they need. Look at *Up in the Air* (2009), where the main character, Ryan Bingham (George Clooney), believes that he needs to achieve the coveted 10-million-mile club. When he finally makes that crucial flight and the pilot (Sam Elliott) walks back to his seat to personally award the honor, Bingham realizes that it's an empty victory. In his lack of attachment to any human being, he has lost what he truly needs to make him human, a deep and satisfying relationship.

In the *Wizard of Oz* (1939), the wizard is revealed, but, rather than being the large and scary figure that our heroes have imagined, they discover he is hiding behind the mask of a machine.

In *In the Heat of the Night* (1967), a white cop (Rod Steiger) believes he's there to catch a murderer, but he's really there to have his prejudices challenged and torn down. The Black detective (Sidney Poitier), whom he first rejected, discovers the murderer.

Figure 16.4 Crazy Rich Asians – The mah jong game.
Credit: Warner Brothers.

In *Crazy Rich Asians* (2018), the main character (Constance Wu) believes she must prevail no matter what, but, in the end, she forfeits the mah jong game with her boyfriend's mother (Michelle Yeoh), letting her win, rather than jeopardize the man she loves. Yet this move allows her to win in the end.

In *Schindler's List* (1993), a successful industrialist (Liam Neeson) believes he's helping his business by conscripting Jewish prisoners (Ben Kingsley et al) to work in his factory, but, in the end, he risks his life to save them from execution by the Nazis.

Figure 16.5 Schindler's List – Oskar Schindler and his Jewish accountant.
Credit: Universal Studios.

In the *Green Book* (2018), an Italian American opportunist bouncer intends to prosper as the driver for a gay Black pianist on a tour through the South, but he comes to feel for the man's suffering and becomes his close friend.

In *Birdcage* (1996), an uptight and homophobic senator from Virginia ends up disguised as a woman and discovering the true value of family.

In *One-Eyed Jacks* (1961), an outlaw (Marlon Brando) determined to increase his riches finds he must take on the unscrupulous sheriff (Karl Malden) of Monterey who used to be his partner in crime. In the end, he brings justice to the town and marries the man's daughter.

Figure 16.6 One Eyed Jacks – Sheriff Dad gets an unexpected visit from Rio.
Credit: Paramount Pictures.

In the *Sixth Sense* (1999), a withdrawn young man who sees spirits enlists the help of a therapist to cure him, only to discover he's already dead.

In *The Sound of Music* (1965), an unsuccessful nun wants to be free of the convent and work as a governess for a large family of talented children, only to marry their father and help save them from the Nazis.

In *Beauty and the Beast* (1991), based on the 1946 film by Jean Cocteau, a frightening monster who was once a cursed prince agrees with a request to return a girl's captive father. But the girl ends up falling in love with the beast and turning him back into a human.

Figure 16.7 Beauty and the Beast – Belle and the Beast.
Credit: Criterion Collection.

What we discover by the end is the value of the crisis. It breaks the mold, bumps us out of the repetitive cycle that our habits have locked us into. By the end of the film, we discover that the crisis was a blessing in disguise.

Some film scripts never quite find their ending, only to discover it during the production process, as in *Casablanca*, or in the post production process, such as in the constructed ending of the dark comedy *The Favourite* (2018), directed by Yorgos Lanthimos and edited by Yorgos Mavropsaridis. In the original script, written by Deborah Davis and Tony McNamara, the two tempestuous and jealous lovers, one the frail Queen Anne of England (Olivia Coleman) and the other her close friend Sarah

Churchill, Duchess of Marlborough (Rachel Weisz), are divided over Anne's affections for her new servant Abigail (Emma Stone). Ultimately, Sarah is banished, and the final scene leaves Anne and Abigail to their fates with each other.

INT. ANNE'S APARTMENTS DAY

Anne lies in bed, she opens her eyes. Sees Abigail sitting in a chair, reading by the window, dropping a Madeleine into her mouth.

A rabbit wanders near her foot, she lifts a foot and traps the rabbit under her foot. It struggles for a moment. She lets it go with a smile.

Anne slides herself out of the bed. Lands on the floor, in pain. Abigail hears a grunt. Sees Anne is on the floor crawling, in pain.

 ABIGAIL
 Anne.

Abigail rushes to her, takes her under the arms to help her up.

 ABIGAIL (CONT'D)
 Darling Anne. Let's get
 you in a chair.

Anne leans on the wall.

 ABIGAIL
 I'm sorry. I -

 ANNE
 I did not ask you to
 speak.

 ANNE (CONT'D)
 My leg. Rub it.

 ABIGAIL
 You should lie down.

```
                    ANNE
          You will speak when
          asked to.

Abigail gets it, drops to her knees starts
rubbing.

                    ANNE (CONT'D)
          I am so dizzy … I need to hang on
          to …

She grabs at Abigail's hair, wraps a hunk
around her fingers, holding it hard. Abigail
winces.
                    ANNE (CONT'D)
          Something …

Abigail rubs, looks over at the cage full of
rabbits across the room sitting staring at her.

Anne winces in pain stares at the wall. Closes
her eyes.
```

This is where the script ends. A rather abrupt conclusion after the audience has committed two hours to get to know Anne, Sarah, and the new servant, Abigail, who, with her ambitions to return to her aristocratic roots, has succeed in driving a wedge between the two lovers.

In the film, the final scene develops beyond the script page with a montage of Queen Anne's 17 rabbits, each of which represents one of her lost children. It blends, through various dissolves, with the images of Anne and Abigail. Though the scene feels slightly surreal, it is grounded in the relationship dynamics that have played out throughout the film, culminating in the sad dissolution of everything that was once cherished in the queen's life. After all, Abigail schemed to become the queen's trusted servant and unseat Anne's old friend, Sarah.

Where at one time she had both Sarah and Abigail vying for her loyalty and affection, now she has neither, and the images of her other losses, the rabbits, compound the regrets. While early on, Abigail won Anne's trust with her sympathetic acknowledgment of the rabbits and their importance to the queen, she now traps one under her foot. Though the film is entitled *The Favourite*, reflecting the struggle between Sarah and Abigail in their drive to secure the favored position with Anne, it's ultimately about Anne herself and how she's grown tired of and felt betrayed by her closest confidants.

Figure 16.8 The Favourite – Stepping on a rabbit.
Credit: Searchlight Pictures.

Figure 16.9 The Favourite – Queen Anne, Abigail and the rabbits.
Credit: Searchlight Pictures.

The Favourite's editorial solution to an abrupt ending is one approach. This is not to suggest that, as a writer, you'll take this approach – though writers do build meaningful montage sequences into their scripts – but that you'll attend to the importance of strong endings based on the dynamics that proceed them. Reading one's script out loud or, if the writer has access to actors, doing table reads can give an excellent sense of what is working

and what is not. While, in the *Made in Heaven* example, it became clear that the film was over when the two lovers met each other again on Earth, the sudden ending in *The Favourite* needed a smoother and more considered transition to fade out.

Notes

1 Shakespeare, William. *Romeo and Juliet*. 1595.
2 Darabont, Frank, and Stephen King. *Shawshank Redemption: The Shooting Script*. Newmarket Press. 30 September, 2004.

17

HINDSIGHT IS 20/20

> The chapter reviews the influence that the final stage of the film-making process has on the beginning of the process. How can the editor's final rewrite speak to the writer's final draft?

Emotional Logic

As movies grew more realistic, audiences came to believe in characters as if they were real people, not just masks of real people. In creating situations and characters, writers teach their audience the rules of a world. One character is cunning and deceitful, another is shy and retiring, another is warm and gregarious. As the story progresses, the audience becomes intimate with these characters and learns what to expect.

Part of the joy and satisfaction of watching a well-told story is the feeling that we know a character so well that we can anticipate how they will react to any situation. Of course, people can change, and we all know the danger of viewing relationships through memory's veil, unwilling or unable to see someone anew. This fresh perspective, which is healing to humans and freeing to the psyche, often does not appear until the third act in films. Until then, we may remain tethered to a preconception of how and why this person acts in a particular way. When this is betrayed without reason or revelation, the audience is thrown off course. Part of the editor's job is to steer the film in the correct direction, to hold to the keel of the premise, and follow the story sextant to a desired location.

An example of this is in the second season of the excellent BBC series based on a bestselling novel, *All Creatures Great and Small* (2022). Tristan (Callum Woodhouse), the brother of the senior veterinarian, Siegfried, is finally given the opportunity to range out on his own and answer a house call without Siegfried (Samuel West) leaning over his shoulder. His first assignment is a scary one – to clean and file the teeth of a huge and aggressive prize horse on a wealthy estate.

DOI: 10.4324/9781003161578-18

Upon arriving with his new vet's bag, he's confronted by the patriarch, who is brusque and confrontational. Eventually, after placing his hand in the jaws of the large-toothed horse and getting kicked in the shins by the unruly stallion, Tristan manages to complete the dangerous procedure.

On his way out, Tristan encounters the daughter of the estate owner, now riding the black stallion. But she is unaware of his inexperience. They chat, she's intrigued, and he invites her to his birthday dinner that evening.

At the birthday dinner, Tristan sits at the table beside the girl and drunkenly confesses his inexperience along with revealing the other subterfuges that he perpetrated throughout the day to convince people of his abilities.

At this point, knowing that the girl is the daughter of the taciturn and skeptical estate owner, the audience anticipates that the revelation will yield some sort of negative reaction, such as shock and dismay. But the scene was not written for the girl to register any response.

Despite the fact that the dinner party's table is crowded with diners, the editor skilfully avoids returning to close-ups of the girl. Instead, the other characters get the close-up treatment, and the girl is all but ignored, featured briefly in a group wide shot. Clearly, if the editor had included close-ups of the girl, it would have begged the question of her reaction to these confessions of Tristan's. Since the dialogue does not follow through on what would have been the upsetting discovery that the girl's date is dishonest and inexperienced, the editor made the decision to avoid her close-ups. Instead, the girl has no reaction. Through this neglect, we are asked to forget about the emotional dissonance that was potentially there.

This is a case where the audience had witnessed the situation and had developed a sense of the characters, but were unable to experience the clear consequences of such a reveal.

Even highly successful films can make miscalculations, and generally the overall power of the film overcomes those missteps. In this case, it is instructional to see what could have been visualized in the script stage, yet was not. Such as the missing jury box in *The Trial of the Chicago 7*. These are subtle and less obvious challenges that filmmakers face and writers must anticipate nonetheless.

Editing suites, directors' sets, and writers' rooms are crucibles. Heated, complex, and sometimes intense. All the material, good and bad, high and low, comes together in these spaces. There is something alchemical about the process. And, like the medieval alchemists, who adopted Mercury as their guide, messenger, and transformer, editors and writers turn base substances into gold, a blank page into *Casablanca*, or 800 hours of footage into *Top Gun: Maverick* (2022).[1]

Figure 17.1 All Creatures Great and Small – The dinner party.
Credit: PBS.

During the Middle Ages, alchemy issued from the waking dream of those who were yet to discover the world of science. They made up explanations for the natural world because the rigors of scientific exploration did not yet exist. They were artists more than scientists.

In the alchemy of film, the transformation from the writer's waking dream to polished script to final cut gives insights into how to take the process to its highest level. The script remains the key to the kingdom.

By analyzing its passage through production and the final editing process, we saw how the writer can focus plot and character in a film such as *Apocalypse Now*, alter an audience's sympathies with a single cut in *Horseplayer*, or evoke sensory aspects of place as in *Dune*.

In *The Power of the Dog* and *King Richard*, we saw how the correct tone with which to begin the story was discovered in post production. In *Prancer, Made in Heaven*, and *Fatal Attraction*, we explored the elements that make a strong and satisfying ending. By looking at *Shame*, we gained insight into how writers can build the all-important filmic moments into their scripts.

In *Pulp Fiction* and *Jurassic Park*, we experienced how the juxtaposition of shots can control time and build suspense within a sequence, while a show such as *The Queen's Gambit* finds ways to leap across time through montage. And for the writer whose scripts labor under too linear a plot, we looked at the fractured narrative in *The Limey* and *Pachinko*. There are many more ways as well. These all rely on the insights and creativity of the writer. When starting a new script, consider some of the

Figure 17.2 Medieval alchemy and the magic of transformation.

approaches outlined here or, more likely, when rewriting, review these chapters and find what resonates with your script's particular issues.

Creativity and Inspiration

At times, one can wonder about the value of films in the larger scheme of things. Life is grand, but it is also full of hardship and suffering. If cinema is merely escapism, an entertainment designed to take us away from our problems for a mere two hours, its value is limited. But film and television stories can also give us an honest look at how life works. They can show

us what it is to grow up, make friends, find a livelihood, fall in love, lose people, have break-ups, die, and be reborn to new possibilities.

Film is as much visual poetry as it is visual music. All this is based on rhythm. The beats of life. That is the purview of the editor, from the child born of the writer.

Cinema's power to influence and to heal has been seen again and again, from the Great Depression to 9/11 to the recent Covid-19 outbreak. Film is a place to turn to find commonality and empathy with others of our species and, in some cases, other species as well. Maybe even an alien or two. As the poet Erica Jong pointed out so beautifully, "People think they can live without poetry. And they can. At least until they become fatally ill, have a baby, or fall desperately, madly, in love."[2]

Sure, as everyone will remind you, especially the producer when you're negotiating salary or a deadline, film is a business. Some people dislike Hollywood because they dislike the dehumanizing aspect of business, of something that puts profit over people. Yet, if it were only a business, it wouldn't affect human beings the way it has for over a century. And some of the kindest, most generous, and most talented people I know are in the film business.

Figure 17.3 A beach.

Credit: Author

Writers earn a living by sharing their lives, or what they understand of life, and telling it in the finest story possible. The best films allow us to experience the joy of learning and discovery. Is there anything more earthshaking for an audience than the epiphany of experiencing, through a character with whom we identify, something that is true? But first, the film must engage us.

Writers, directors, editors, and most artists confront, from time to time, the fear that their creative impulses will evaporate, that they'll run out of ideas. But creation is an amazing force that goes beyond our ability to fully comprehend it.

On a walk along the beach, we marvel at the endless grains of sand below our feet and the profusion of stars above us in millions of galaxies, each unique. There are so many creatures upon this Earth that it is impossible to describe them all. This is creation, a generative process without beginning or end. When we create, we tap into this special realm and share dominion with something greater than ourselves, whether as a writer at the keyboard or an editor at the editing console. The next step is always the first step, that brave foray into the unknown realm of the blank page. Along the way, the journey can be full of detours, missteps, doubts, unexpected encounters, and startling revelations. Screenwriting is rewriting. Understanding the process helps ferry you confidently along that path. And, in understanding the distant realm of the editor, you can utilize their techniques to elevate your script to new levels, making it even more engaging and polished and original.

Notes

1 *Variety*. April 13, 2022.
2 Jong, Erica. *A Century of Recorded Poetry*. Rhino Records. 1996.

INDEX

Pages in *italics* refer to figures.